WATERCOLOR
A New Beginning

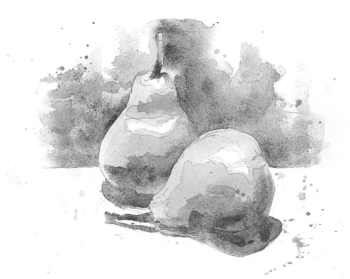

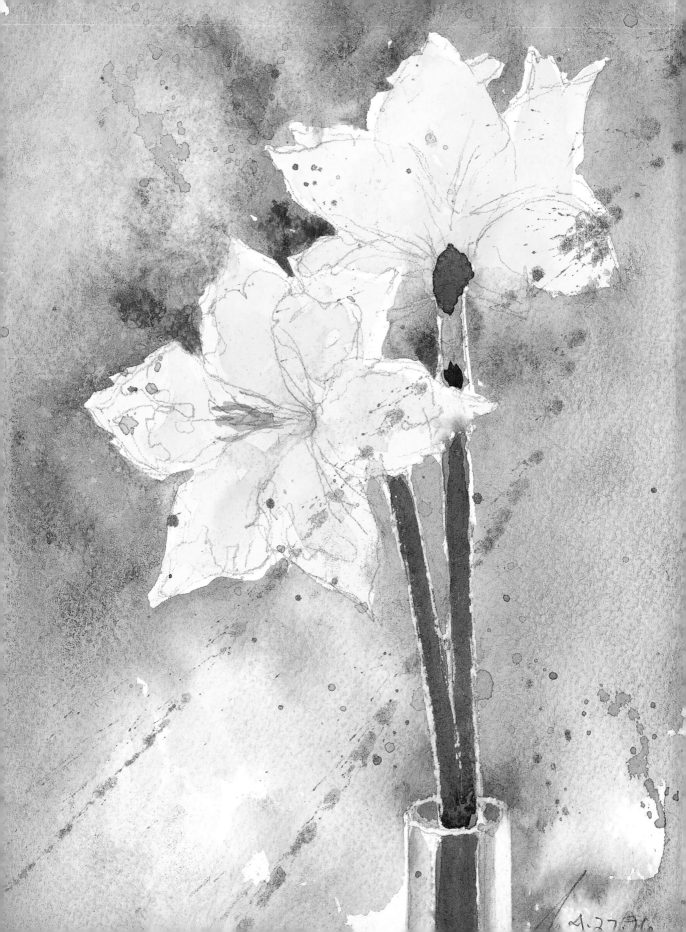

WATERCOLOR
A New Beginning
A Holistic Approach to Painting

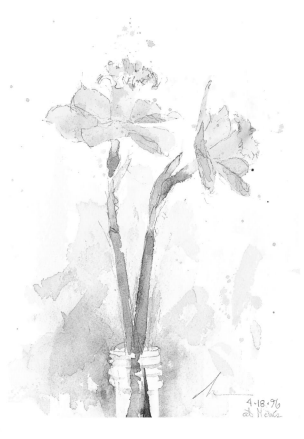

ANN K. LINDSAY

Watson-Guptill Publications / New York

This book is dedicated with love and gratitude to my mother, Katherine Lindberg.

Thanks, Mom.

Acknowledgments

First, I'd like to thank my teachers, Jack Flynn, Peter London, Frederick Franck, and, through her book *Drawing on the Right Side of the Brain,* Dr. Betty Edwards. This book began with them. Thanks also to the many others who shared their experience, insights, and joy of living, both in person and through their words.

A special thanks to my therapist, Pat Phillips, for helping me realize the child I was hadn't gone anywhere. Not only is she still here, she played a large part in the creation of this course.

I am deeply grateful to all of my students for their questions, insights, enthusiasm, and support, especially Mary Sherwood, Betsey Belvin, Gail Thornbury, Debbie Rimkunas, Bob Renner, Linda McGraw, D. A. Sweeney, and Fran Popner. Thanks also to Erika Olmsted, Katherine Lindberg, Wendy Gipp, Dolores Lovegreen, and again, Mary, Betsey, and Linda, for generously sharing their early work.

A great big thanks to my mom, Katherine Lindberg, my daughter, Morgan Lindsay, and Alan Hoglund, for their encouragement, suggestions, and unfailing support. Also to my friends Jeanne Ferland and Asa Zoesman, and again, Alan and Morgan for their company in the drawing chapter.

Thanks to my friend Margaret Weinland for her help with the photography, especially in the early stages; Morgan, for her help later on; Bill Creevy for sharing his experience; and Mike Barton at Bennington Photo for his knowledgeable assistance and cheerful patience; and to the Rensselaer County Council for the Arts for the S.O.S. grant that helped pay for it all.

Thanks to "Cheap Joe" Miller, Winsor & Newton, and Teaching Art Limited for generously supplying the materials shown in this book.

And thanks to the folks at Watson-Guptill—to Candace Raney for responding to my query and seeing the potential, and to Marian Appellof for her brilliant and sensitive tuning of the manuscript.

Copyright © 1998 Ann K. Lindsay

First published in 1998 in the United States by Watson-Guptill Publications, a division of BPI Communications, Inc., 1515 Broadway, New York, NY 10036

Library of Congress Cataloging-in-Publication Data

Lindsay, Ann K.
 Watercolor : a new beginning : a Holistic approach to painting / Ann K. Lindsay.
 p. cm.
 Includes index.
 ISBN 0-8230-5638-4
 1. Watercolor painting—Technique. I. Title.
ND2420.L557 1997
751.42'2—dc21 97-30967
 CIP

Manufactured in China

First printing, 1998

1 2 3 4 5 6 7 / 04 03 02 01 00 99 98

Edited by Marian Appellof
Designed by Patricia Fabricant
Graphic production by Hector Campbell
Text set in Perpetua

Picture Credits

All artwork is by the author except as noted here; numbers refer to the pages on which work appears.
Betsey Belvin: 66 left, 83 bottom, 93 left, 124 left, 135 bottom, 141 top, 143.
Jeanne Ferland: 89 top right, 90 bottom right, 91 top, 96 bottom, second from left, 110 bottom left.
Wendy Gipp: 105 all, 131 top, 134 bottom, 142 bottom.
Alan Hoglund: 89 center right, 90 top right and center right, 94 top left, 96 bottom, third from left, 110 center right.
Linda McGraw: 40 top, 66 bottom right, 75 bottom left and right, 129 bottom, 138 top and center, 141 bottom.
Erika Olmsted: 65 top, 135 top and center, 138 bottom, 142 top.
Katherine Lindberg: 40 bottom, 51 bottom, 65 bottom, 66 top right, 74 bottom, 95 all, 115 all.
Morgan Lindsay: 89 center left, 90 top left, 91 bottom, 96 bottom left.
Mary Sherwood: 34 all, 51 top, 74 top, 113 top right and center right, 124 bottom right, 127 top, 131 bottom, 132–33, 136 all, 139 bottom.

All photography is by the author except as noted here.
Page 20 and back flap: Margaret Weinland.
Page 99, top right: Morgan Lindsay.

CONTENTS

INTRODUCTION

This book is the result of my quest to find a way of teaching watercolor that would work for everyone, that would let anyone experience painting as an enjoyable, playful, and magical part of his or her life. It also came from my own growing understanding that making art is an intuitive process, yet as far as I had seen, it had always been taught from a rational point of view. Increasingly, this just didn't make sense. I began to feel that teaching techniques, rules, principles, and theories first was simply not appropriate and, more often than not, shut down a person's own creative process.

My students at the time were all adults, mostly women. Watercolor painting was something they had always wanted to do. The enthusiasm was there; how could it be kept alive? Helping people open up to their own art experience became much more important to me than teaching them how to "control" the medium. I wanted to nurture my students' art spirit, for art is the voice of the soul, and is one of the finest, deepest ways we have of expressing ourselves as human beings.

While asking myself these questions, I was in therapy, a large part of which consisted of inner child work. As I began to understand that the child I once was had not gone anywhere but was still inside and needed to be loved, accepted, and believed in, I began to see many parallels in my students. Their inner kids were all there—painting brings them right out front—and, as all children do, they needed to feel accepted as they were, and believed in as well.

I began to realize that what people needed to learn was not how to paint but how to *play*—how to explore and enjoy themselves, instead of worrying all the time if what they were doing was "good" or not, or if they were doing it the "right" way. (There is no one right way to do it.) I wanted my students to relax, to be able to

accept what they did as part of their becoming, and celebrate the fact that they had done it at all. I had always urged them to play with their paints at home, but no one did. I came to see that it wasn't because they didn't want to; they couldn't. They wanted to be serious, to practice till they "got it right."

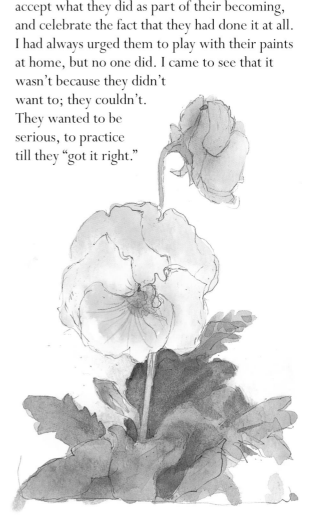

But the more serious they became, the less they seemed to be enjoying themselves, no matter what I said.

I began to see that teaching rules first resulted in a preoccupation with the finished product. I wanted instead to see my students having more fun with their process. If I took away all the rules, what was left? The essence of the creative process: play! If I gave my students support, reassurance, and encouragement to explore instead of telling them "how to do it," their intuition and imagination would become stronger and their ease of artistic expression would unfold naturally. With a couple of pointers from me on seeing and the nature of the creative process—hints on navigating unknown waters—they would be off! I myself needed to learn how to be there for them, and yet get out of their way.

This meant putting play first in the class. Later on, after my students had begun to discover and believe in their own ways of doing things, I could introduce a few rules and principles, which they could use—or not.

As I developed this approach, insight after insight followed in response to my experience and that of my students. The course continues to evolve and change a bit with each new class, yet the underlying premises remain constant:

Art is the voice of the soul, personal and individual.

The desire for quality is inherent.

An intuitive process needs a primarily intuitive approach.

Skill and ease (mastery) come from familiarity.

Watercolor likes to be danced with, not controlled.

Intuitive learning is playful and fun. It is about exploring new territory, seeing what happens and not thinking too much. This book is more about teaching you how to play with watercolor than how to paint with it. You need to learn how to play, how to enjoy your process, because this is the way you'll find out how you paint. All any artist can really share with a student is how it is for herself or himself. This is how it is for me. I hope this book will help you discover how it is for you.

So please, let yourself explore and play to your heart's content! Watercolor is alive. It moves. It's magic. It dances differently with everyone. Enjoy the dance! That's what you came for!

Part 1

BEFORE WE BEGIN

OPENING THE DOOR

I often hear from people that they enjoyed drawing or painting when they were very young, but then stopped. Why? Every time it was because of critical comments someone made about their work that caused pain. Then, their inner voice started saying "It's no good" because a drawing or painting wasn't coming out quite the way they had intended or didn't look "right," and at some point they decided they couldn't do it, that they had no "talent." Sound like anyone you know?

There are only two reasons people feel they aren't able to express themselves in visual terms, drawing or painting things they love in their own way: critical, humiliating words from the outside, or criticism from the inside. It is not a lack of talent or creativity but the fear of humiliation that causes our creative spirit to withdraw. Art is our heart coming right out of us onto the paper, into the world; no wonder we feel so vulnerable and easily discouraged, especially when we are young. What is important to know, however, is that the creative spirit doesn't go away; it goes inward. And the part of us in charge of protecting ourselves closes the door and locks it.

If you are reading these words you have begun to open the door. You have felt something stir inside, a resonance, when you see watercolor paintings or perhaps a sunset or the light on a bowl of fruit, just so. Or seen an artist sketching or painting and felt yourself yearning to do the same. Your creative spirit, your artist within, has been calling, and you have heard on an intuitive level, with your heart, a little voice saying, "Let me out." Wonderful! Now, in the spirit of keeping that door open, let me tell you a few things that may help.

Being of Two Minds

We are spiritual beings in physical form. We have an inner, spiritual world of heart, soul, feelings, and intuition—and an outer, physical world in which we need to survive. Our brain has two hemispheres. The right, which I refer to as the intuitive mind, has the qualities and capabilities of perceiving the spiritual world and things of a more inward nature, while the left, or rational, mind is geared to perceive and understand the physical world and ensure our survival in it.

In her seminal book *Drawing on the Right Side of the Brain,* the artist and educator Dr. Betty Edwards describes the roles each hemisphere plays in our creative process, and explains how and why the right hemisphere is uniquely suited to making art, while the left one isn't.

In our modern society, we have placed great importance on developing the rational mind. Our physical survival is, after all, very important. Yet sometimes we want to feel feelings, speak from our heart, make art, play just for the fun of it—and find it very difficult to do these things.

The rational mind loves "doing," and likes feeling "worthwhile" by doing things right, best, and fastest. It is uncomfortable being still, quiet. The fast track—going faster and faster, being driven to succeed, succeeding only to find that one feels empty and is left wondering what it was all about—is only one perfect,

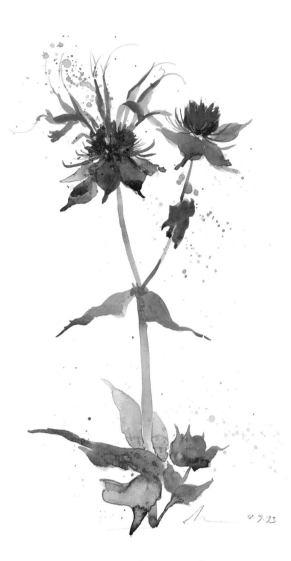

if sad, example of what happens when our rational mind runs amok.

The intuitive mind, on the other hand, knows the worth of "being." It is very comfortable with stillness, accepting of things as they are—including ourselves! It is our intuitive

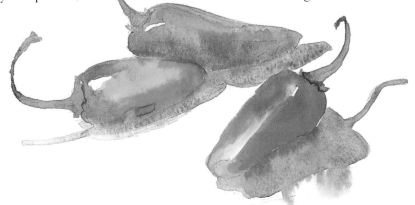

mind we open to when we meditate, daydream, find ourselves in a creative reverie, or get lost in doing something we enjoy so much we "lose all track of time." Being happy with things just as they are, and happy with ourselves just as *we* are, are perceptions of the intuitive mind.

Because our rational mind perceives the physical world as being the "real," hence more important, one, it tends to dismiss or devalue our spiritual world, which can't be seen, touched, or measured, yet is just as real and perhaps even more important.

We literally are "of two minds," and things begin to work ever so much better when our rational and intuitive selves are in concert. Then we feel ourselves supported from within rather than picked apart, and enjoy experiencing ourselves as whole human beings—and that includes our artist within!

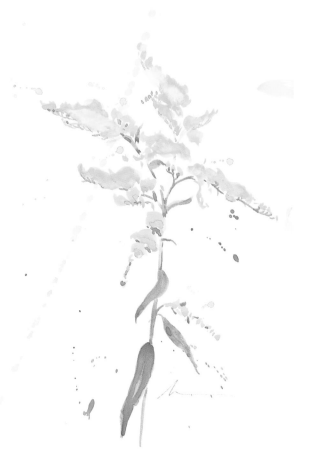

Managing Your Inner Critic

A lot has been written in recent years about the inner critic. This is an aspect of the rational mind that has run amok. It is supposed to help us analyze what we're doing, not judge things in terms of right, wrong, good, or bad.

A few new phrases can help immensely in transforming our inner critic from harsh judge into the guardian it is intended to be. For instance, instead of saying, "I'm no good at this," how about: "This is new to me. I can see it will take me a while to feel familiar with it. It's a little uncomfortable now and then, but that's OK. It passes. Mostly I'm really enjoying myself." Instead of saying, "I can't do it," how about: "I'm having some difficulty here; it will take more time than I thought. That's OK. This is really important to me, and I know that my skill and ease will grow as I continue to paint." Instead of saying, "This painting is no good," how about: "It

doesn't look like what I'm seeing and I want it to. What is it that's different? How might I change it?" Instead of saying, "I've ruined it," how about: "Hmm. What's happening here? It's different from what I intended, but let's keep going and see what happens."

Can you hear the difference? Can you hear how the judgmental words discourage the creative spirit, don't let the work live, and shut down the process? Can you hear how the descriptive, analytical words keep our hearts open so the creative spirit keeps flowing and the process continues?

When the inner critic says something isn't any good, it's really trying to protect the artist within, to protect your heart from humiliation; if you already believe something isn't any good, nobody else can tell you what you don't already know.

Another thing. If you are new to something, say watercolor painting, and your inner critic judges your early efforts as "no good," what does it mean, anyway? Ask it. Chances are, the answer you will get is that your work doesn't look like anything it's seen before, or like the work of someone who has been painting for a long time and is very familiar with the materials and processes. Well, of course it doesn't. It's new, and it's yours. You're new. Your rational mind needs to learn to trust your process. It's coming from a sacred place. Skill and ease come from time and experience. Mastery comes from familiarity. No effort you make is ever wasted. You are always learning, and everything you do counts.

Perhaps your inner critic tells you something doesn't look finished. Well, how can it if you are in the middle of a process? Again, your rational mind is trying to protect you from possible humiliation; it wants your work to look finished all the time just in case anyone comes by and sees it.

We can begin to change things by revaluing our intuitive selves, giving voice to our creative spirit and creating an atmosphere of mutual respect between our rational and intuitive minds.

So, whenever you become aware of your inner critic pouncing all over you, reassure it that you are doing fine. You need to explore, and you are learning from everything that happens.

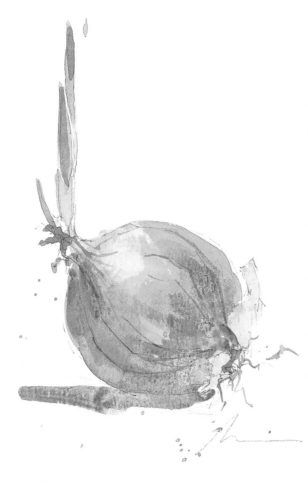

How to Use This Book

This is your course. There are no rules here except for this one: no negative self-talk—no "It's not very good" or "I'm not very good." At any given time, you're doing your best.

I encourage you to do things whichever way you want. You probably haven't had permission before now to explore art freely, without concern for the end result. There is no such thing as failure here; it's all learning.

Give yourself time to play, to paint, to enjoy yourself. It is in your own playing and experience that your true learning happens. There's no need to rush; relax. Take yourself through the book one chapter at a time. Pretend you're taking a class that meets once a week or so, and work on your own in between. If you have to skip a week now and then, don't worry. Go at your own pace. Linger where it feels good to play around for a while. You are getting to know your artist within. Enjoy each other's company.

How Do You Paint Grass?

"How do you paint grass? or shadows? or sky?" These are the first questions most beginning painters ask. A teacher might answer with something like "What grass? The tender green grass of early spring? The golden grasses of autumn? The dry, brittle grass poking through the snow in winter?" Or perhaps with this: "The question is, how will *you* paint grass? It won't help you if I tell you how *I* do it." (If you already knew the answer, you wouldn't have asked the question in the first place.) Other artists might show you how, sharing their techniques with you.

I suggest that you rephrase the question and ask it of yourself: in other words, "How might I paint grass?" This triggers a response from your artist within. Using the word "might" opens you up to possibilities from which you can choose.

Further asking "Well, what's one way?" can make it more manageable if too many possibilities occur to you. Then do it and let it be. See what happens. As the renowned painter and teacher Robert Henri said with regard to technique, "the whole fun of the thing is in seeing and inventing."

A Word About the Demonstrations

The demonstrations in this book are meant only to give you an idea of what I am talking about, not show you "the way." There is no "one way" to do any of this; only your way now, tomorrow, next week. After you read through a demonstration, close the book and let yourself see what happens when you begin to play. While learning about watercolor in this playful way, you are also learning to tap into and trust your intuition.

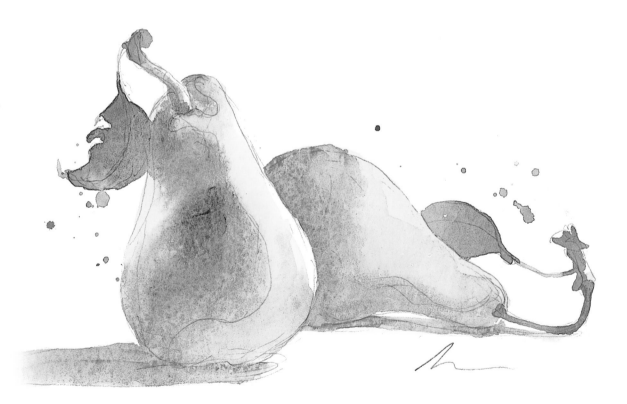

Just in Case

There is a chance you might experience some personal resistance. "This is silly," you might say. Yes. It is silly. So? "But I don't know what I'm doing." That's OK, too. It may feel very uncomfortable because it is so unfamiliar. Making art is not verbal, it is emotional. You are touching your inner self, waking it up and asking it to come out into the world.

You are taking a chance by going into the unknown, and naturally will feel confused and afraid at times. But hold on. Keep going. You can do it. Did you learn to swim as a child? You were scared. You didn't trust the water. You tried to float and you were so tense you sank. The instructor had you play around with kick boards, put your face in the water, and blow bubbles. Bit by bit you got used to the feel of the water, and after a while you weren't so scared. You began to feel the buoyancy. You laid back, let yourself go, relaxed, and then, suddenly, you were floating in water! All the words your teacher used to explain it couldn't really describe it. Painting is like that. You get used to the feel of it, used to being in the process, and then, after a while, you find you're letting it happen.

You have everything you need inside you already. You just need a little help letting it out. I'm here to say it's OK if you feel afraid. Know that *whatever* you do, it's OK. It's important that you paint, that you experience your love of life through art if it's calling to you, even if only in a whisper. You don't have to know what you're doing ahead of time to enjoy painting. You just have to get started and not judge yourself, and accept whatever you do with a sense of wonder.

Think of this book as offering encouragement, company, and support rather than instruction. It is meant to demystify the creative process so you can begin. Once you are painting, you will find the mystery is still very much there, only now you are participating in it.

MATERIALS

You don't need a lot of supplies to get started painting in watercolor; beyond three or four tubes of paint, some paper, a couple of brushes, and some water and a container for it, there are just a few additional items to have on hand.

One of the biggest bugaboos for beginners is the fear of using materials. From Mom, Ranger Rick, and practically every schoolteacher we ever had, we learned the lesson "Don't waste." Unfortunately, however well intentioned that message was, unconsciously we heard it as "Don't use materials unless you can produce something 'worthwhile' (read 'good') with them—and good the first time! Don't use a lot of anything, and heaven forbid, don't use it up!" So much for creative exploration.

What you need to hear now is, "Use up those materials!" It's OK. This is about respecting and appreciating your materials, not wasting them.

The Bare Essentials

To get started painting in watercolor, you'll need these basic materials:

- Watercolor paints
- Brushes
- Paper
- Palette
- Water container and water
- Paper towels or tissues
- Masking tape

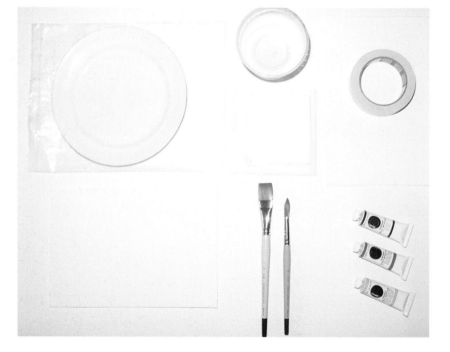

Watercolor Paints

For all the lessons in this book you will need just four tubes of transparent watercolor: a red, a yellow, and a blue (called the primary colors, because they can't be mixed from any others) and, later on, a brown. In watercolor painting, our white is the white of the paper. The paper is where the light comes from, reflected through transparent layers of color.

A full color palette may be beautiful and tempting, but in the beginning it's a lot to keep track of. Instead, you will be mixing your own oranges, violets, greens, grays, browns, and blacks using only the three primary colors and eventually your brown. By doing so, you will come to understand a great deal about color mixing and color theory, learning from your experience of what's happening on your paper.

Purchase higher-quality paints if you can afford them, as they tend to be more brilliant than the lower grades. I recommend tube paint rather than the kind that comes in dry cake form (called pan paint) because it is so accessible to the brush, so ready to go. Some well-known brands of watercolor paint are Da Vinci, Winsor & Newton, and Grumbacher. If money is a great concern, buy whatever you feel comfortable with. You will have fun no matter what.

Another type of watercolor paint is gouache (pronounced GWASH), which is opaque rather than transparent. It can be used in conjunction with transparent watercolor; white gouache is especially useful for creating bits of light on top of a painting.

For your red I suggest red rose deep or any other "cool" red (meaning that it has a slightly bluish quality; more on this and on "warm" colors later in the book), because it will make a clear violet and also a nice orange.

For your yellow I suggest either a "warm" yellow such as cadmium yellow light or aureolin, or a "cool" one, such as lemon yellow or Hansa yellow.

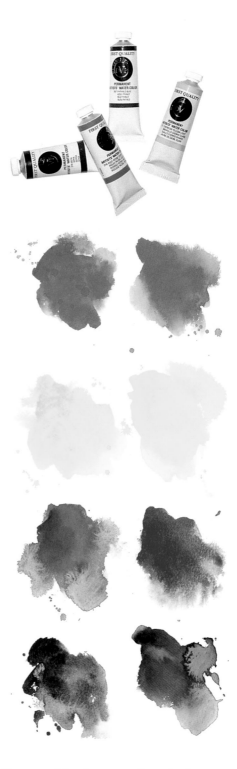

For your blue I suggest French ultramarine, phthalo (THAY-lo) blue, or Winsor blue (Winsor & Newton's name for phthalo blue).

For the brown I suggest that you use either sepia or Vandyke brown.

Brushes

Purchase brushes made specifically for painting in watercolor, not oil or acrylic. These need not be expensive, and for our purposes, synthetic is fine. Buy a 1"-wide wash brush (one with hairs that are flat, forming a straight, square edge) and a #10 or #12 round brush (one with hairs that form a pointed tip) to get started with. Now or later, get a #2 or #3 rigger (or liner) brush, which has long, thin hairs that form a fine point. This little brush makes a very narrow line yet holds a lot of paint, so you can make long lines or lots of shorter ones without a refill. It got the name rigger because it was often used to paint the rigging on ships.

Your brushes will last longer if you don't leave them standing in your water container.

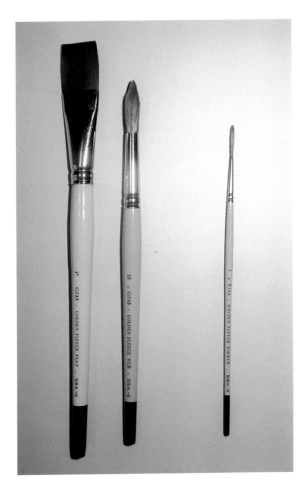

There is water-soluble glue inside the ferrule (the metal collar) holding the hairs together with the wood, and if water seeps in, the hairs will start to come loose. Also, the hairs will bend and the brush will lose its spring.

Some artists wash their brushes out with soap and water when they are finished painting. I don't, but I suppose if I were using very expensive brushes I might. Once again, it's really what works for you.

Paper

One of the many wonderful things about painting with transparent watercolor is the beautiful paper we can work on. It is a rich experience to watch our colors flow over its lovely surface.

I recommend that you get 140-lb. cold-pressed, acid-free paper to start on. What does all that mean, you ask? Well . . .

- Paper described as 140-lb. means that 500 sheets weigh 140 pounds; 300-lb. paper is heavier (thicker), 90-lb. paper is lighter (thinner).

- Cold-pressed paper has a pebbly texture produced by pressing the sheet through unheated rollers; hot-pressed is pressed through hot rollers to make it smooth; rough paper is barely pressed after the sheet is formed and thus has more texture than cold-pressed.

- A paper described as 100 percent rag means it is made from all cotton or linen fiber.

- Acid-free means there's no acid in the paper. Normally, paper made from wood pulp contains acid, which causes the paper to turn yellow and become brittle with age, like old newsprint. However, paper made from acidic materials can be treated so that this won't happen, and will be labeled pH neutral.

Full-size sheets (22 x 30") of good paper bear the manufacturer's watermark, which you can

After you've become accustomed to using good paper, go ahead and try anything you like. I paint in my sketchbooks and on bond paper, and love how the paint moves on a smooth surface. I try to use papers that are acid free or neutral pH, but I don't make a "thing" of it. And if you simply feel more comfortable starting out with less expensive paper, then go ahead! You're the boss. The experience of drawing and painting on anything is more important than having good-quality paper.

Palette

Get a white plastic palette with a large mixing area and a snug-fitting cover. See what you like. I use the John Pike palette and like it a lot. Even a plain white plate and a plastic bag to cover it with when your painting session is over will work fine, too. (Once you use the plate for paint, though, don't use it for food.)

Covering the paints between painting sessions helps keep them moist. If they do dry out, you can still use them. Just spray some water on them to wake them up. (This is what you'd do if you were using pan—dry cake—watercolors.) You can also squeeze out more moist color from the tube right on top of the paint that has dried if you want.

see by holding the sheet up to the light. If it reads the "right" way, you are looking at the top or front side of the paper. The back may have a slightly different texture; you can paint on either side. One of the most popular brands is Arches; it is available at most art supply stores and holds up well to all kinds of explorations without falling apart, including scrubbing (to remove paint) and scraping. You may have heard it said that "with watercolor, you have to get it right the first time. Once you put it down you can't change it." Well, sure you can—just as you can put paint on the paper, you can take it off, too! You may not get back to the white, but you can usually lighten things up quite a bit. And if it's good watercolor paper, it won't fall apart.

Get full-size sheets to start with. Each full sheet, torn into eight pieces, will give you two or more hours of pleasure; most of the exercises in this book call for six pieces. I encourage you to use the good stuff from the very beginning so that you get comfortable working on it. You're worth it.

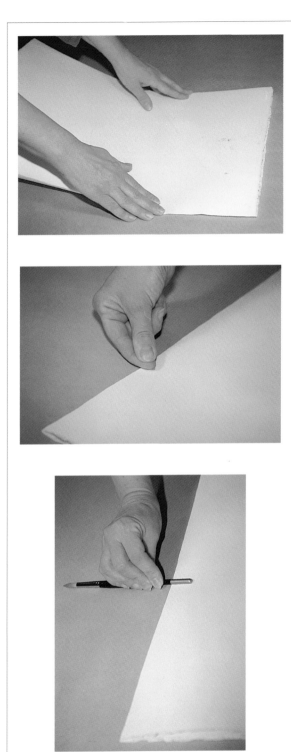

Tearing Your Paper

To tear a 22 x 30" sheet of watercolor paper into eight pieces, first fold it in half and make a sharp crease to divide it in two, lining up the edges by moving your hands downward opposite each other. Then, with the back of a fingernail (going very slowly so you won't get a friction burn) or the wooden handle of a paintbrush or another tool that won't scratch, burnish the crease to break down the paper's fibers.

Once you get your crease, reverse the fold and do the same thing again four times, twice on each side. At that point, the paper should tear apart easily. Tear out and away, not upward, and follow your hand to oppose the physical force of this strong paper.

That's it. You now have two half-sheets; halving them, you get four quarter sheets, which torn in half give you eight pieces that measure approximately 7½ x 11". (If you're using a block or a pad of watercolor paper, tear out some sheets so you have a pile ready to go.)

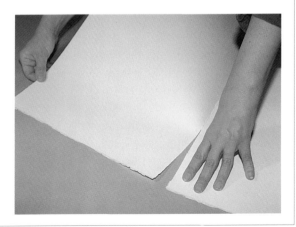

Remaining Basics

You will need some water and a container to put it in; use anything that's handy. Paper towels or tissues are good for mopping up spills, wiping your brushes, and even lifting paint from small areas on the paper. You can use masking tape to fasten your paper to your working surface and keep it flat and still while you paint. That's enough to get you started.

Other Very Handy Items

A few more things you'll find useful and enjoy having are these:

- Board
- Sponge
- Spray bottle
- Mop pad
- Scrubber
- Brush holder
- Pencil and eraser
- Sketchbook
- Small watercolor-paper pads
- Viewfinder
- Mats and corners
- Magnifying glass

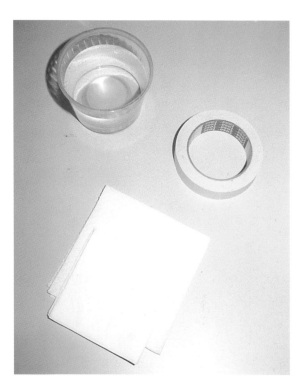

Board

A board is useful to support your paper. You can tilt it, work at an angle, and tape or stretch your paper on it. It can be a piece of Masonite, ¼"-thick plywood, heavy cardboard, or gatorboard—anything that is rigid yet fairly lightweight. Although I use a variety of boards, my favorites are made from ¼"- or ⅜"-thick foam core cut to size and covered with clear contact paper. They last for years. A 12 x 16" board will accommodate a quarter sheet or smaller piece of paper. You'll need one for the chapter on exploring washes.

Sponge

Sponges come in handy for all sorts of things, such as cleaning paint off your palette and removing color from your paper; you can even paint with them.

Spray Bottle

One of my favorite toys is a spray bottle. It is useful for many purposes, such as misting colors on the palette to keep them moist and dampening your paper both before you paint on it and while you're working.

Mop Pad

A folded-up washcloth, piece of paper towel, Handi-wipe, or the like can be used as a "mop pad" to soak up the excess water from your brush after you rinse it out.

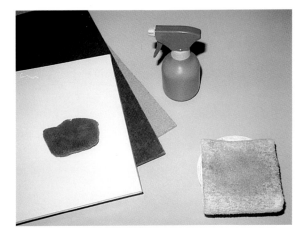

Scrubber

A "scrubber"—a small stencil brush, worn-out oil painting brush, or even a Q-tip—is very handy when you want to remove or lighten a small area of paint or soften a hard-edged area in a painting that has dried.

Brush Holder

When I need to carry my brushes to a class, an outdoor painting session, or when I'm traveling, I roll them up in a bamboo brush holder and toss it into my bag without a care. The brush tips are protected, and if they're wet, they will dry out without getting mildew. A bamboo place mat with a rubber band works great.

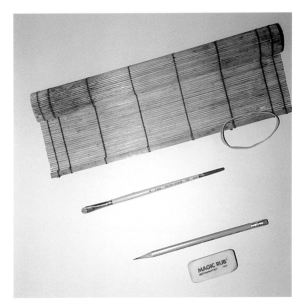

Loading Your Palette with Paint

Squeeze a generous amount of each primary color—your red, yellow, and blue—onto your palette. (No need to squirt out your brown right now; you won't use it till about midway through the book.) If you're using a palette with wells, leave some empty spaces in between for any colors you may add

later on. If you are using a plate, put the three primary colors around the rim and use the center area for mixing.

Pencil and Eraser

A regular #2 pencil is fine for making notes on your paper and, eventually, drawing. As for erasers, I like the white plastic kind the best; kneaded erasers too, provided they haven't been used to erase soft stuff like charcoal, which can leave a dark smudge where you really don't want one. Just about any soft eraser will work, including the one at the top of the pencil!

Sketchbook

There are lots of different kinds of sketchbooks; I especially like the Aquabee Super Deluxe #808 for watercolor, which has acid-free paper and comes in three sizes: 6 x 9", 9 x 12", and 11 x 14". I've noticed that students usually like to start with a smaller one, then move on to a bigger size.

Small Watercolor-Paper Pads

Treat yourself to a couple of these soon and start doing little paintings in them just for fun.

Viewfinder

A viewfinder is a little frame that's fun to look through and will be helpful later on. I use an empty 35mm slide mount or my fingers for this.

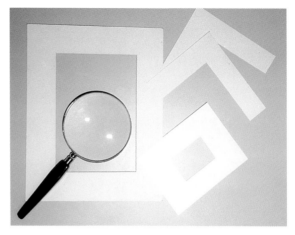

Mats, Corners, and a Magnifying Glass

To further explore your adventures and have more fun with what you've done, try the following:

- Get a couple of large index cards and cut a 1 x 2" opening in one of them and two square corners from the other.

- Soon, pick up a couple of precut mats from a photo or art supply store, one with a 4 x 6" opening and one with a 5 x 7" opening. Mats make everything look more special, and help you see more clearly what is happening on your paper.

- And for an even closer look at the marvelous things that happen in your explorations, have a magnifying glass handy.

Now, let's start *using* this wonderful stuff!

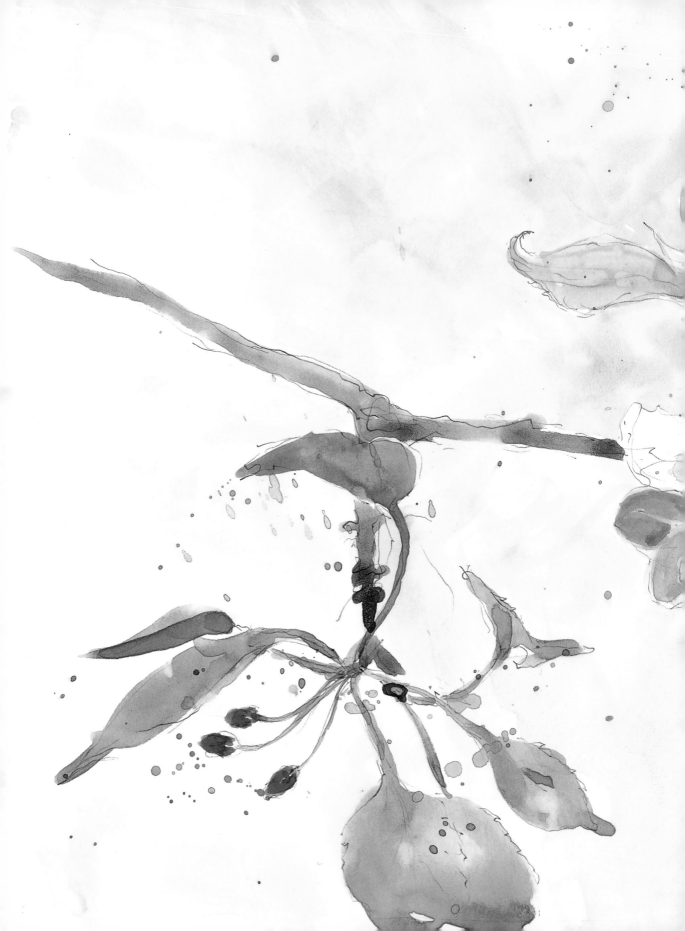

A NEW BEGINNING

MEETING THE PRIMARY COLORS, PART I

Let's meet our partners——our paints, brushes, and paper. Let's begin to get the feel of all this.

The primary colors are red, yellow, and blue. They are called primary because they can't be mixed from any other colors, so we need to begin with them. Mixing the primary colors in various combinations gives us the other colors——oranges, greens, violets, browns, grays, and blacks——the secondary, tertiary, and neutral colors. (It's OK if these words aren't familiar to you. They will be after the next few lessons.) Our white, remember, comes from the paper.

Here we go!

Experience / Explore the Primaries in Pairs

To begin, we're going to explore the following primary-color pairs:

1. red + blue
2. blue + red

3. red + yellow
4. yellow + red

5. yellow + blue
6. blue + yellow

Get out your gear and set up your "studio." You'll need six or more pieces of paper—⅛ of a full sheet, about 7½ x 11" each. Tape one piece lightly to the table or a board. It will want to curl up when you put water on it, and this will hold it flat.

Relax. Close your eyes for a minute. Breathe. Take a moment or two to "be" where you are. Let the outside world stay outside. Feel your happiness. It's playtime!

Wet your paper. You can use your 1" wash brush, your #12 round, the spray bottle, or a sponge; I usually use my 1" wash brush.

Look at the light reflecting off the wet paper. Depending on how much water you put on, your paper will be damp, very moist, wet or puddling (perhaps each of these in different areas), and there will be different degrees of shine. (Don't be overly concerned with remembering or analyzing any of this; just watch what happens.)

Now, choose one of those gorgeous colors. Which one is calling to you today, perhaps a little louder than the others? Wet your brush. Introduce yourself. Say, "Hello, red (or blue or yellow). My name is . . . May I have this dance?"

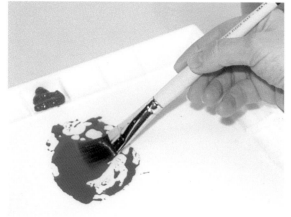

Take your brush and bring some color out onto the mixing area of your palette and smooth it around. It doesn't need to be a lot. This gives you a chance to see its consistency and even it out.

Get some water with your brush to thin it a bit. Pick up more paint and water as you need to make a nice puddle.

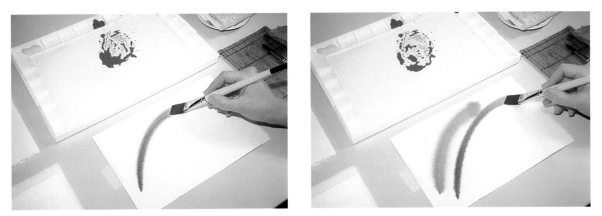

Then, bring the color from your palette, put it down on that beautiful wet paper, and watch what happens.

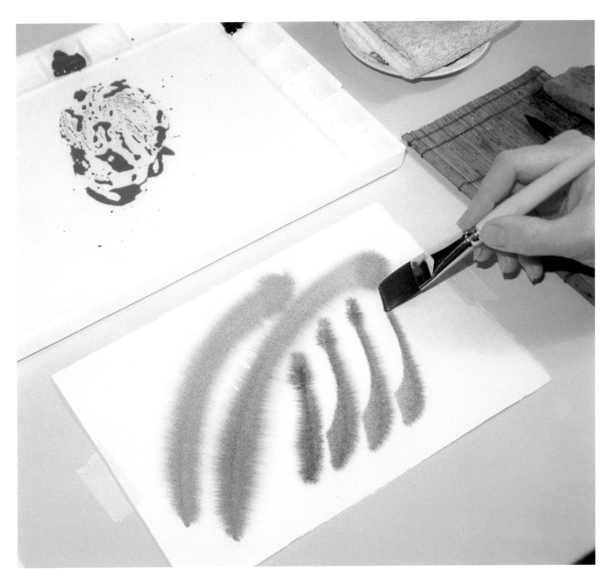

Relax. Enjoy yourself. Let the brush do the painting. Let your arm and hand move as they will. Feast your soul on the color and the experience. Play to your heart's content. You are painting. The dance has begun!

Note your response to the color. Do you feel happy? Sad? Calm? Excited? There is no correct response, and the response you have at this moment might be different from how you feel at another time. You are simply beginning to bring feelings you usually may not pay much attention to up into your conscious awareness. You are developing your color sensitivity. This is a new language you are speaking—a language of the emotions. This may seem awkward at first, but again, it's only because it's new to you.

See how the color is lighter when there is more water and less pigment so the paper shows through more. See how the color is darker when you use more pigment and less water. See how the pigment moves differently depending on how wet the paper is.

When you are ready, clean out your brush. Yes, some pigment will be lost to the water, but it's OK—it's part of the process.

Now, pick a second color to join in the dance. Which one will it be? Smooth it out a bit on the mixing area, adding some water as you wish, and bring it onto the dance floor.

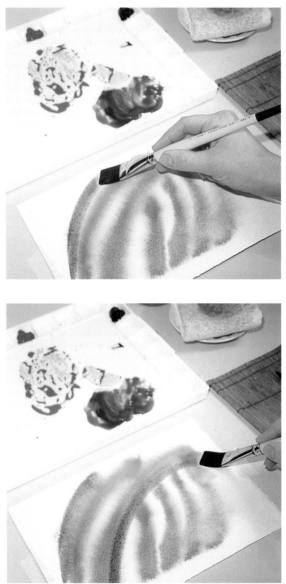

Is your paper dryer now? Do things move differently? Do you want to wet it again? Go ahead. Do whatever you want—it's your paper.

As the two colors come together, new colors are created. Do you notice yourself having different feelings now?

Load your brush with more color as you need it. Oh, and don't worry if a bit of one color gets on another in the palette wells. It happens all the time. It is possible to clean off pigment in the wells and not lose much by misting it and "wicking" up the water with a damp brush or a twisted corner of paper towel. (Wicking is demonstrated on page 48.)

Continue to explore what these two colors have to say to each other (and you).

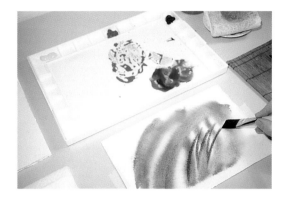

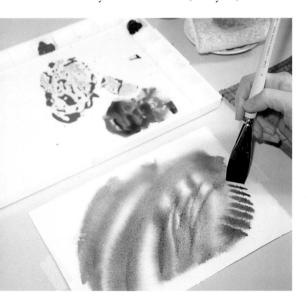

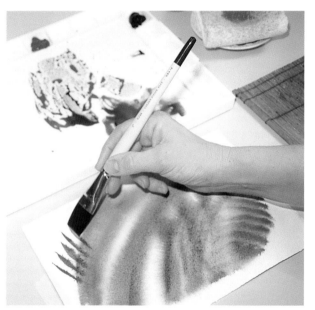

And that brush—it's dancing too!

Long, wide strokes.

Narrow ones.

Up on its edge.

Twisting, twirling.

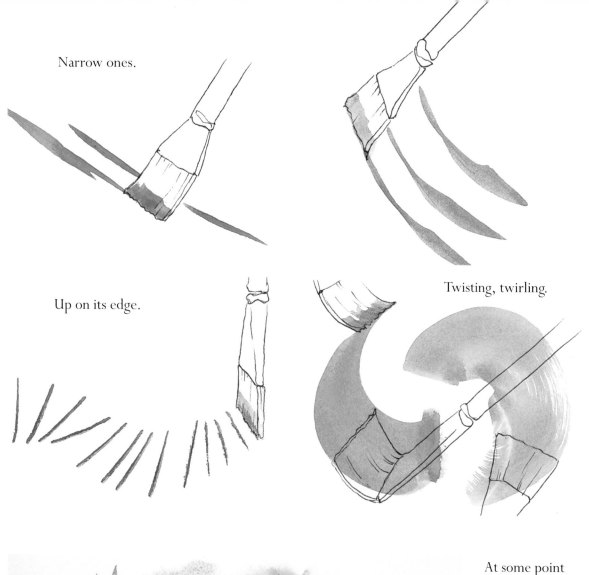

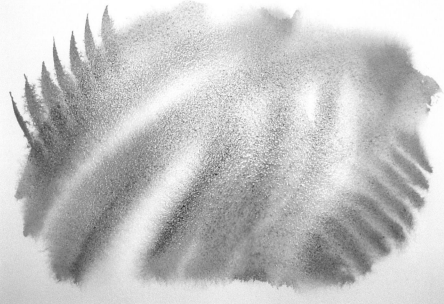

At some point you will have danced enough on that piece of paper. Sit with it for a while. Take in these "marks from the heart." See what your artist within has done. Feels good, doesn't it? Pat yourself on the back. You are doing it! You are painting! This is the beginning.

Tape down another piece of paper, wet it, and reverse the sequence, starting with the second color first. (You may want to change your water at this point if you haven't already.) Now this color has a chance to solo on the fresh, wet paper. How do you feel when you see it on the paper, all by itself?

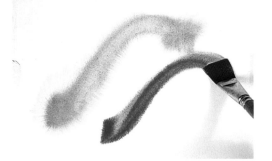

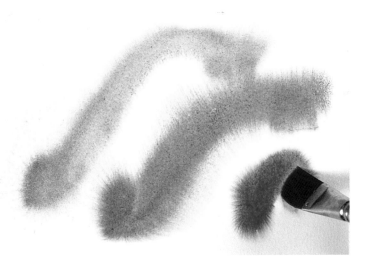

Again, pick up more color as you need it.

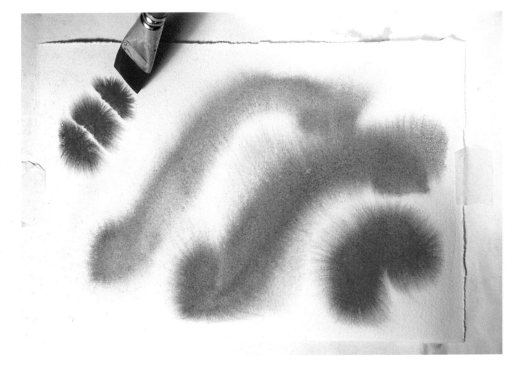

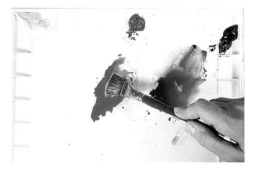

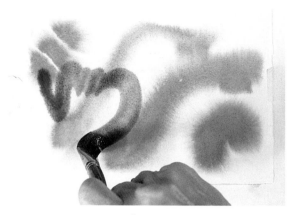

When you're ready, rinse your brush and bring back your color's partner (the color it danced with before). Watch what happens.

Play . . .

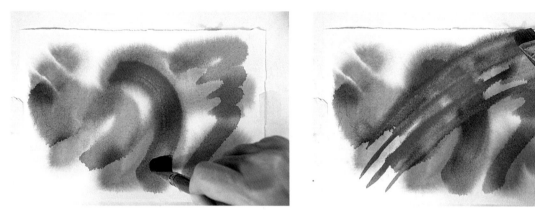

Explore . . .

Enjoy!

On your third piece, it's the third color's turn. Eventually bring one of the other colors into play. On the fourth piece, reverse the order of your chosen pair. On the fifth piece explore the remaining combination, and on the sixth piece, reverse the order. Got the idea? Great! I bet it's been a long time since you let yourself play like this.

Wipe all or part of your palette mixing area clean with your sponge whenever you need new space in which to mix more colors. At different points, take time to look at what has happened and reflect on your experience, simply letting it sink in, increasing your awareness. If you find images coming, that's fine; accept them with grace. Your imagery may even look the way it did the last time you made a picture. How old were you? Four? Eight? Ten? Your artist within has been waiting a long time for this, and will pick right up where he or she left off.

Now close the book. Invite your inner child/artist within out to play. Do it your way. See what happens. Have fun!

How Did It Go? Did you enjoy your experience? Were you comfortable being "in the process"? Or not? What happened that you especially liked? What did you learn? Any surprises? Funny as it may seem, I have found that playing in this open-ended, seeing-what-happens sort of way can be kind of scary for some folks—threatening not physically, but emotionally. Now, however, you are grown up and can protect your inner child. Be careful with whom you share what you're doing, and let those you love know how important this is for your well-being. Criticism and judgment are entirely inappropriate. Instead, you need understanding, encouragement, and admiration.

Keep going. Keep playing. It will become easier. This is your beginning. Enjoy yourself. After your paintings are dry, you can play some more on them if you like.

Here are two of Mary's primary-color "dances."

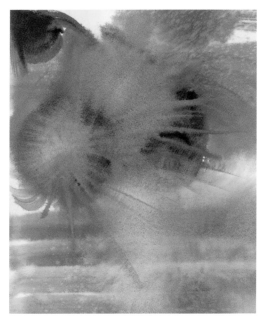

Flattening Your Paper

If you want to get your watercolor paper flat after you've worked on it, just iron it! Place the paper face down, lightly mist it, and, with your iron set on cotton, gently press it. If you've painted on the back side, too, slip a piece of bond paper between the surface and the iron.

When You're Done

Spend some time looking what you've done. These explorations have all come from your heart and have a lot to teach you. Using your small corners, isolate little areas of your paintings to wander about in, or to see more clearly some of the things that happened—soft edges where the paper was damp, hard edges where the paper was dry, no edges at all where the paper was really wet; the different ways the colors combined; how the different brushstrokes look. Find little places that particularly sing to you. Or, using a small mat cut out of a piece of card stock, look for little paintings within the bigger ones. You may find some mini compositions that you like so much you decide to cut them out and put them on cards, or in little plastic frames with magnets for your refrigerator door or the fridges of friends and loved ones. Are you surprised? Do you find yourself saying "Wow, look at that!?" Do you feel a little magic going on?

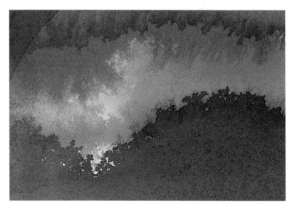

One more way to enjoy and learn from your painting explorations is to take them to bed along with a magnifying glass and "read" yourself to sleep, wandering around the colors, the edges, the brushstrokes. A magnifying glass can bring you even deeper into this amazing, wonderful world you've created.

MEETING THE PRIMARY COLORS, PART II

This intuitive, wordless way of learning—playing, exploring, seeing what happens, being in the unknown, accepting and taking it all in—may seem very new to you. Though we are actually learning this way all the time, it is very different from how most of us think of learning. You may love this approach right away and find it exciting. You may find yourself relaxing, relieved of any pressure to create a product, thoroughly enjoying the process. In art, the process is the point; the product is what happens.

Playing in this open-ended way is very important. It awakens and strengthens the imagination, opens the gate to intuition, and stimulates creativity. This is no small potatoes. You're going into the world of your imagination, where you don't have to "know" everything ahead of time. Indeed, the very nature of the creative process means that you can't. And that's OK.

A Review of What You've Learned

Now, just to reassure your rational mind that you really are learning a lot in this playful, intuitive way, here are a few of the many things that went on in the preceding lesson.

You've already begun to experience some painting "techniques":

- *wet-on-wet,* applying watercolor to wet paper and seeing what happens;
- *wet on dry,* applying watercolor to dry paper and noticing how the paint behaves differently from when you work on wet paper; and
- *brushwork,* making various kinds of marks with your brushes.

You have begun to gain an intuitive under-
standing of:

- *soft edges,* which result when you stroke paint
 onto paper that is damp, and
- *hard edges,* which you get when you stroke
 paint onto dry paper.

You've gained some knowledge of color theory
by beginning to see:

- what the primary colors do when they get
 together, creating *secondary colors:* orange (red
 plus yellow), green (blue plus yellow), and
 violet (red plus blue).

And you've begun to experience *values,* the
degrees of a color's lightness or darkness, by
seeing that:

- the white of the paper is your lightest light;
- when you use a little pigment with a lot of
 water, your colors are lighter; and
- when you use a lot of pigment with a little
 water, your colors are darker.

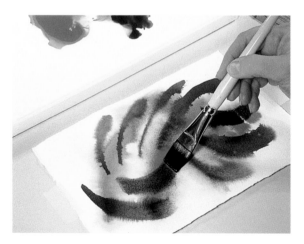

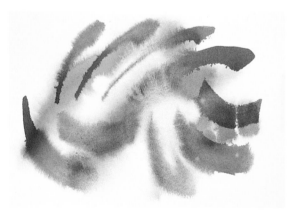

Did you notice that watercolor changes as it
dries? It keeps moving after you've stopped!
Also, it gets lighter as the water evaporates.
Things that you thought were really dark turn
out to be not so dark after all. Look at the
difference: wet paint . . .

. . . and dry.

How about that? And here you were, playing
the whole time.

Ready for more? Let's go!

Experience / Explore the Primary Colors in Threes

In this lesson, everything's the same as in the preceding chapter's exercises, except now you will be adding your third primary to each "dance." Have fun exploring your colors in the following combinations:

1. red + yellow + blue
2. yellow + red + blue

3. red + blue + yellow
4. blue + red + yellow

5. yellow + blue + red
6. blue + yellow + red

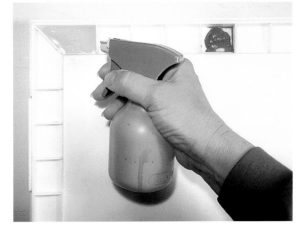

Again, you'll need six or more pieces of paper. Tape the first piece to your work surface, and give your paints a spritz of water with your spray bottle to wake them up.

Relax. Close your eyes for a minute. Breathe. Settle into yourself. Let the outside world spin on its own for a while. Then choose your first color. Which one is calling you the strongest this time? Now wet your paper and let the music begin!

This time red's calling me.

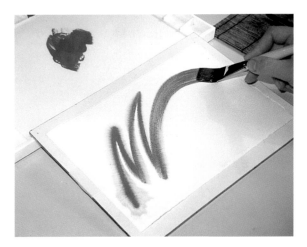

Don't hurry yourself. Enjoy watching what's happening. Whenever you feel it's time, bring in your next color. I'm ready for blue, and as I stroke it onto the paper, I watch what happens, exploring and enjoying it.

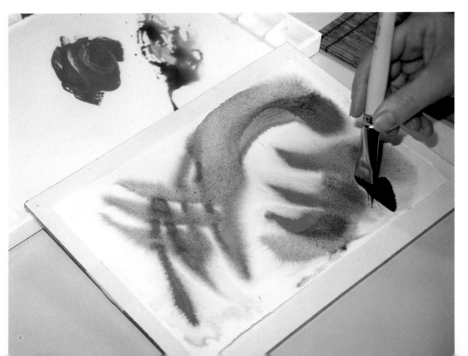

Now I bring my yellow out onto the paper. Wow! See how the colors move and mingle!

Now I try some more blue.

At this point, I think I'll let this one rest for a while.

Are you surprised by how much lighter things look when they dry? Compare this dried version to the previous step, when it was still wet.

When you're ready for another piece of paper, set your first one aside (I like to date my explorations and note which colors I used), tape down a new sheet, wet it, and take off again, this time reversing the order of the first two colors. Enjoy your response as each color goes down.

If you were standing right here, watching me do this, you would see the water glistening, the paint moving, the colors mixing together on the paper, and you'd be so excited that you wouldn't be able to wait to start playing on your own paper—and you'd never look back to see what I had done. Not once.

If you are raring to go, these pictures have served their only purpose, which is to spark your enthusiasm. I can't say it enough: Nothing *I* do is meant to show you "how to do it"; you already know how. So, see what happens. See what you like; this is how you become aware of your own sensibilities. If you do something with your brush you love, do it again, and again and again. This is the beginning of your own style, your own techniques—how you like to paint, to say things.

Take your time. Enjoy yourself and what you see happening. Close the book now and have fun.

How Did It Go? Did you enjoy combining all three of the primary colors? What happened that you really liked? How about where that red and yellow come together just so, or how pale and delicate that blue is? Or where the blue over the red made violet, maybe a deep, blue-violet? What about those hairy little edges where the yellow goes into the red, or that stroke where two colors were on the brush at the same time?

Here are a couple of explorations by Linda (top) and Katherine (below).

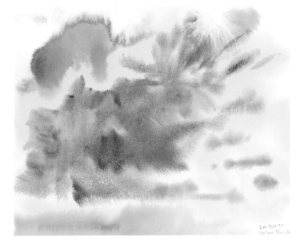

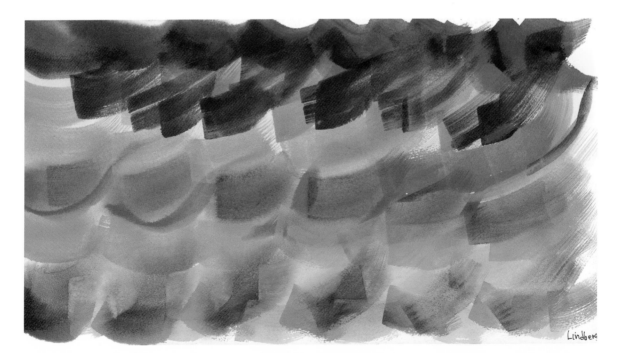

Again, spend time with your painting explorations. Look at them and listen to them; your heart is speaking to you.

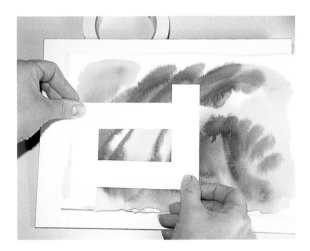

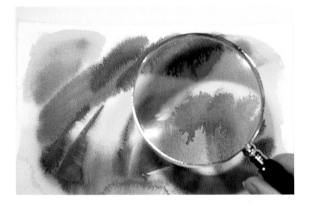

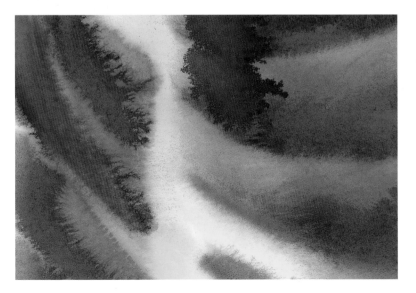

Blooms

Have you gotten any "blooms" yet? These are what happen when a puddle of watercolor is left to dry, or when you drop water into an area of color. Aren't they beautiful? Look at those amazing edges.

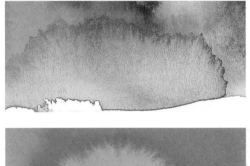

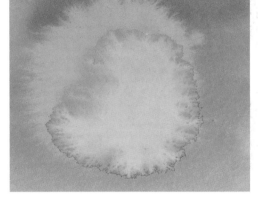

More Fun

Do you have a sketchbook yet? Begin playing in it. Fill a few pages with more brush and color play, and maybe try painting one or two simple little subjects. Just let what happens happen.

EXPLORING THE SECONDARY COLORS

You've begun to have some fun exploring and playing with your primary colors, mixing them in an intuitive way, watching what happens. All the while, you've been learning not only how to paint, but also how to explore. Already, you've been mixing colors:

- *on the paper—bringing your paints to the surface and letting them mix there, maybe giving them a nudge or two; and*

Or maybe it was the round brush....

- *on the brush—perhaps by accident, perhaps on purpose—by picking up two or more colors at the same time and bringing them to the paper that way, noticing the exciting things that happened.*

Now we're going to explore mixing our primaries to create the secondary colors.

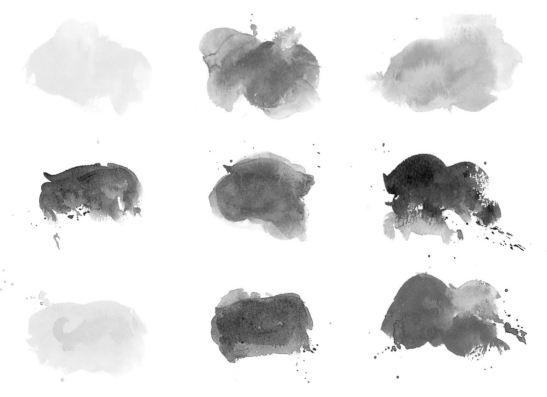

Experience / Explore the Secondary Colors

Today, have some fun mixing secondaries by combining the following colors in 1) a linear, rational way; and 2) a playful, intuitive way:

- yellow + blue = green
- yellow + red = orange
- red + blue = violet (purple)

You will need six or more pieces of paper, and this time you'll work on it dry, adding water as you wish.

I put down a patch of my first color.

You might want to test your colors on a piece of scrap paper first before recording them on the watercolor paper. See how the tiniest bit of blue completely changes the character of the yellow?

Linear Color Play

Mist your colors to wake them up. Squirt out some fresh color wherever you need it. Begin with whatever colors call to you. (I suggest you start your mixing with the lighter of the two or you'll wind up with a puddle of color on your palette much bigger than you really want.) I'm going to start with yellow and go toward blue.

Use either brush. I'm using my 1" wash brush because I like the neat little squares it makes. I could make squares with my round brush, too. And who says they have to be squares, anyway? If you are left-handed, feel free to start in the right corner instead of the left.

Then I reach for my second color, blue. Just a touch makes a big difference!

Now I add a touch more blue to my palette. I test it again for fun . . .

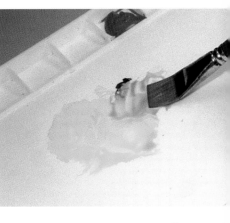

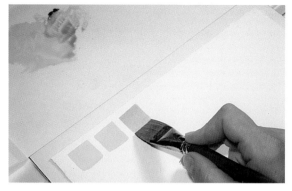

. . . put it on my paper, and continue on in the same fashion, working my way toward blue.

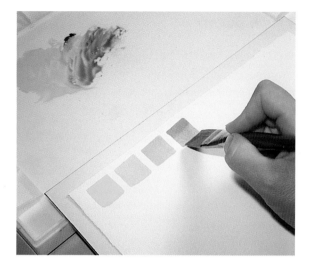

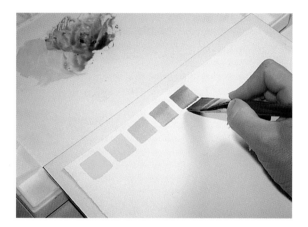

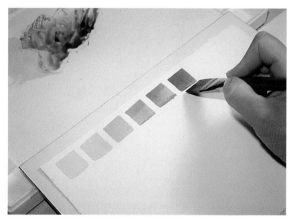

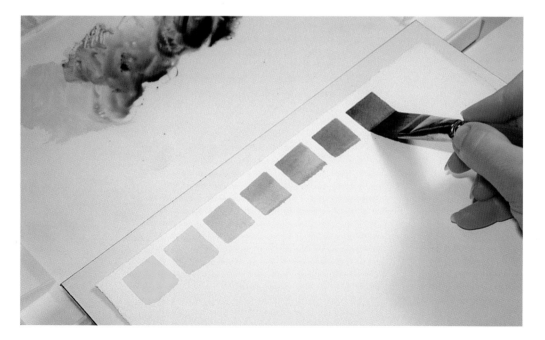

Oh, these greens! It's spring here as I'm making these colors, and by doing so I feel I'm touching the season somehow, in a very deep, close way, taking it in, being a part of it. Even, in a way, creating it.

When I get toward the end, I clean off my brush because there's still some yellow in it, and I want to make sure it's all out so I can get a clear blue for my last square.

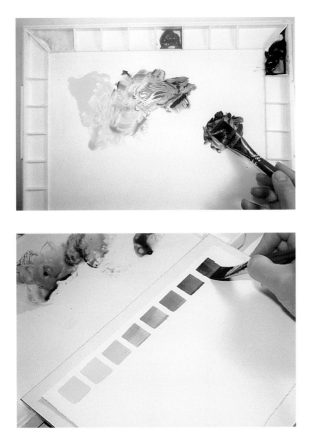

Linear mixing is a lot of fun, putting down those little patches of color, step by step, going from one color to the next. Don't worry about making a perfect "chart." It doesn't matter. You playing with your colors is what matters—whatever happens! Another way to look at what you're doing is that you're playing on your palette and recording each color as you make it.

When you get to blue (or whatever color you chose to finish with), you can do either of these things:

1. Go back to your original color. You are learning so much by doing this—getting the feel for how to change a color slightly, making it warmer with a bit more yellow or red, and cooler with a bit more blue.

2. Go on to explore *tints*, which are the lighter values of a color and are often referred to as "the lights." (The darker values of a color are called *shades*, and are often called "the darks.") To make your colors progressively lighter and create a range of tints, you can use more water with your paint (so that more paper shows through) or wipe paint off your brush or, with a tissue, dab an area you've put down to remove pigment.

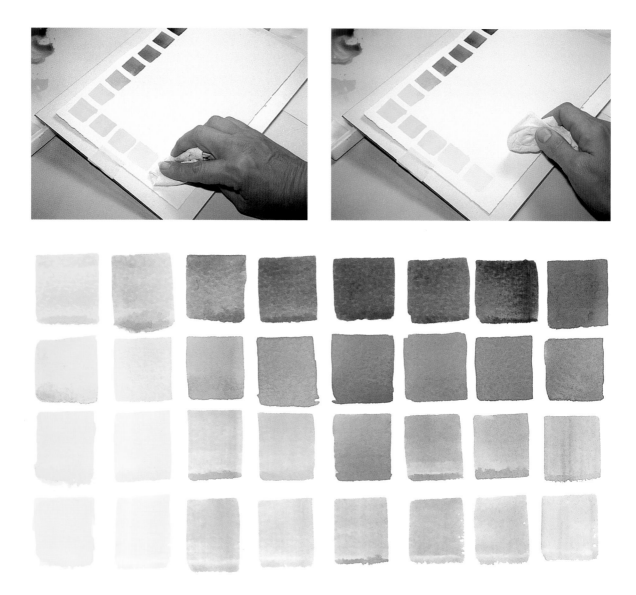

Look at the lightest tints in these studies and begin to think of them as your "whites." In addition to the white of your paper, they are all ways you can talk about white: white in sunlight, in shadow, warm and cool whites, rose whites, peachy whites. White isn't "just white" anymore, is it?

You are beginning to get a feel for how to lighten all your colors, how much water and how much pigment does what—not in the rational sense of two parts this to one part that—but in an intuitive sense, getting a feeling for what you are doing.

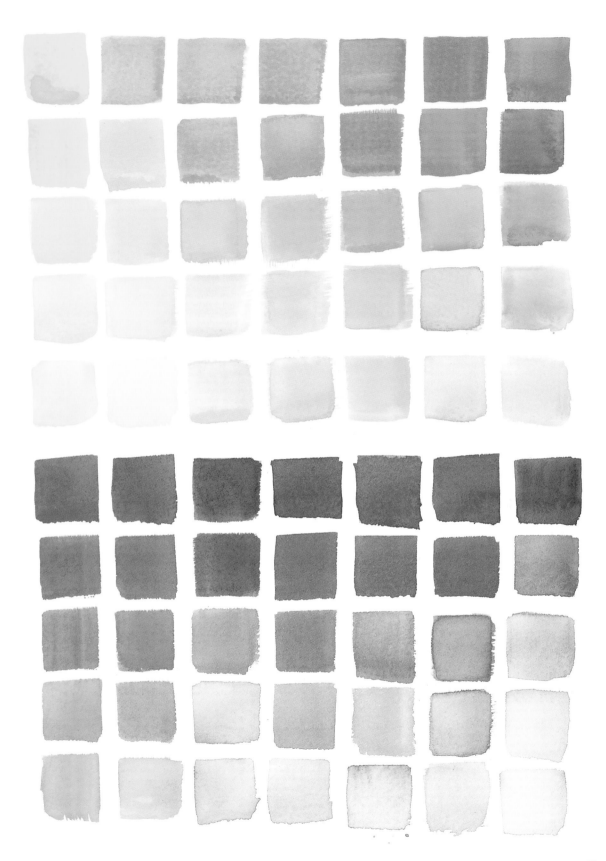

Tertiary Colors

As you explore the secondary colors, you are also making tertiary colors. A tertiary is a mixture of a secondary and one of the primary colors. These combinations give us such colors as yellow-green, red-violet, yellow-orange, blue-green, blue-violet, and red-orange. Aren't they beautiful?

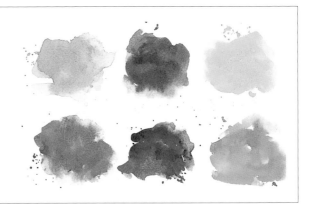

Wicking

The colors in you palette wells may have "company" by now—blue visiting yellow, yellow visiting red, and so on. This happens all the time, but the more you paint, the less it will concern you; most of the time I just leave it. However, if you ever want to tidy things up a bit—say, for instance, you want to make a bright, clear orange but your yellow is covered with blue—"wicking" is a great way to clean off the colors in the palette wells without losing a lot of paint. Just get out your handy-dandy spray bottle and mist your yellow. Most of the "visitor" should dissolve into the water and you can wick it away with a twisted corner of tissue or paper towel, or a clean damp-dry brush (a brush that you have put in water and then wiped with a paper towel).

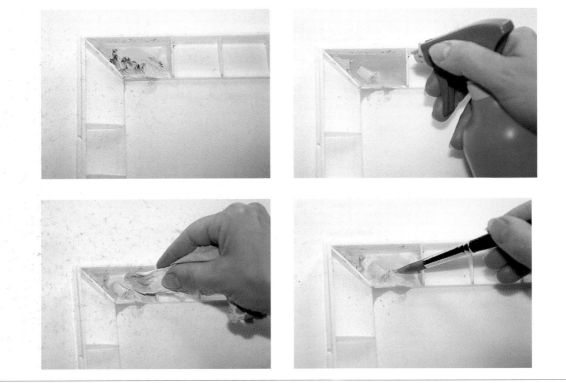

Intuitive Color Play

Now play with these wonderful colors you have been making, using your round or flat brush and working on dry paper, adding water whenever you wish. Let your inner child have free reign. Let your rational mind sit back, relax, and enjoy seeing what happens. Your artist's eye is watching all the time. It's so very important to get the feel of this wonderful stuff—how it moves, how the colors play with each other and the water—and also important that you learn to play again. Have fun!

On page 50 are my intuitive combinations of red plus yellow and red plus blue.

On page 50 are my intuitive combinations of red plus yellow and red plus blue.

<div style="border">

A Color Reference File

Make pencil notes on your secondary explorations about which paint colors you used. These then become a color reference file, which can be very helpful to refer to in the beginning. If you're wondering how to make a certain color, you'll probably find it or something close to it on one of your sheets and be able to see what you did to get it.

</div>

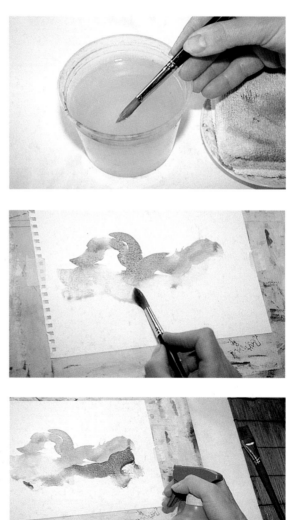

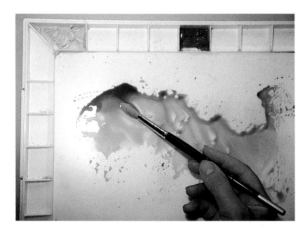

How Did It Go? How did mixing the different colors feel? Did you really click with the linear way, loving the order and "sense" of it? Did you find it difficult and confusing? That's OK—it doesn't matter. Whatever you did is fine.

Why not put all of your explorations up on the wall and enjoy them all together. All those beautiful colors—and you made them! Isn't it amazing?

Now, have some more fun with your mats, corners, and magnifying glass.

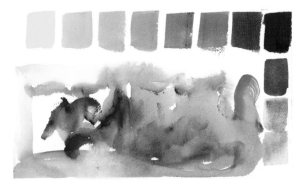

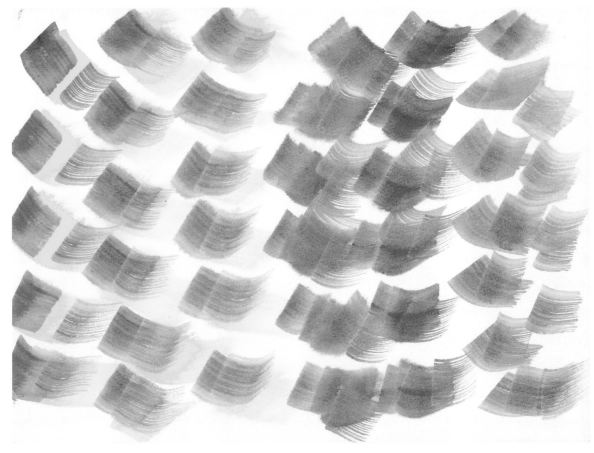

Here are explorations by Mary (left) and Katherine (below).

<div style="border:1px solid">

More Fun

Play in your sketchbook and little watercolor pad, using up a few pages to do your choice of the following:

- *More brush play.*
- *More color play.*
- *Maybe paint a little something simple.*
- *Maybe paint another one (or two).*

</div>

Experience/Explore the Color Wheel, Part I

The color wheel and color theory are things the rational mind has cooked up to help us understand and see the patterns of color relationships. Color wheels are fun to do, and you may find it helpful to make one for yourself so you can see how various kinds of color relationships work.

On an 8½ x 11" sheet of paper, draw twelve circles (or another shape) that form a ring, as in the illustrations shown here. Fill in the spaces, putting yellow at the top. You can fill in all three primaries first, then secondaries, then tertiaries. Or you can go from yellow to red, red to blue, and blue back to yellow.

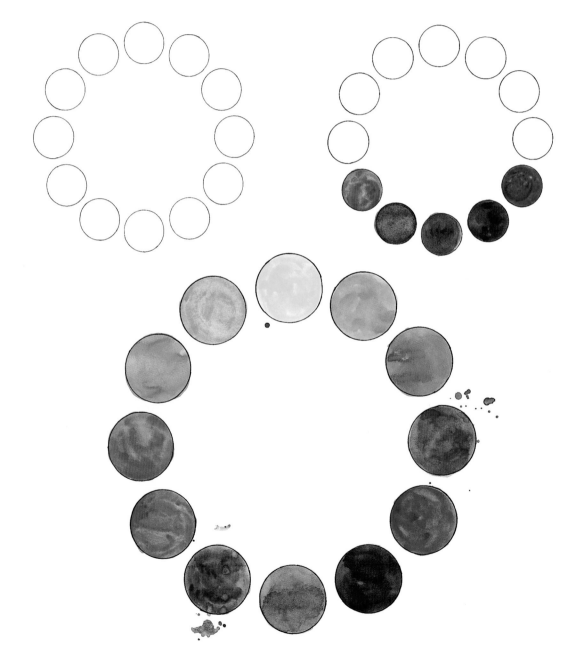

A Place for Your Art

If you don't have one already, start thinking about making a place just for you and your art, somewhere you can leave things out and set up. A table in a corner is enough to begin with. If your painting materials are set up and ready to go, they will beckon you to play with them, and it isn't a big deal to sit down and use them, even if for just ten or fifteen minutes. Since it's not a big production, you can do it more often and may find it just sort of slides into being a part of your life. Many of my students have told me what a difference this has made, and how great they felt about it. (Of course, having your own place set up for painting doesn't mean you *have* to work there. I often find myself drawing in the kitchen or living room, maybe because of a certain quality of light, or just because it's where I want to be.)

Find a section of wall where you can tape up your paintings. It's such fun to see them up, and you'll notice a difference in the way you perceive them. They will look more important somehow, more "official." And, if you put a mat around any of them—well, you've already experienced the amazing difference this makes in your perception. Framing a painting with a mat gives it "breathing room" and separates it from everything around it, helping us to see its specialness.

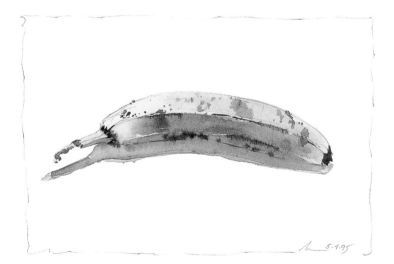

VEILS OF COLOR: WASHES AND GLAZES

Let's take time now to delve into one of watercolor's most unique qualities: its transparency. In addition to the way watercolor paint moves, the fact that we can see through it to the light of the paper below, and even through layer upon layer of color, lends even more to its mystery and allure. Let's explore washes and glazes.

Experience / Explore Washes

What, exactly, is a "wash"? A wash is a thin layer of watercolor, often over a large area. That's basically it. It can be as controlled or as free as you wish. You can lay a wash on paper that is either wet or dry. There are basically four kinds: flat, graded, variegated, and multicolored. Whatever we call it, it's always a thin layer of color.

Have fun exploring the four different kinds of washes on wet or dry paper. In addition to your regular gear you will need your board, masking tape, and a hair dryer (optional).

A flat wash is a single color applied evenly over the whole area.

A wash that goes from light to dark is called "graded," "gradated," or "graduated."

A variegated wash goes from one color to another.

A multicolored wash is composed of different colors here and there.

Stretching Paper

There are many ways to stretch paper. I find that just taping with masking tape is usually enough for my purposes, and I recommend it to beginners because it's quick and easy. Spending a lot of time preparing a single sheet of paper can make you feel inhibited about what you do on it. I want you to feel relaxed, not worried about ruining a sheet of paper.

When I'm sure I'll be getting the whole sheet pretty wet, I usually tape it down on all four sides, applying the tape one side at a time, stretching the paper a bit as I go. I burnish it by running my fingernail along the edges so that water won't seep under it. (Sometimes water seeps under anyway. Oh well.)

Make two playing fields on one quarter sheet of paper at a time by putting a piece of tape down the middle of it to divide the area in half. Burnish all the edges to prevent paint from seeping under the tape. Then prop up your board so it's tilted; when you're creating a wash, let gravity help you. (I almost always work with my board propped up with something.) You can work either horizontally or vertically; it's up to you. Try these different washes. You'll find that they tend to go fairly quickly. No need to labor here. Have fun!

Flat Wash

Laying a flat wash is a skill graphic arts students and commercial artists need to be pretty good at. For us it's really not necessary, though you may find that you love flat washes.

You can wet your paper or leave it dry—it works both ways. For this demonstration, I begin on dry paper.

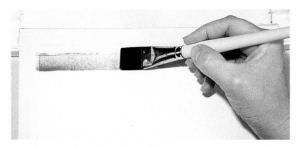

Load your brush and make a continuous stroke across the top of the paper.

Mix up a nice big puddle of thin color (a little pigment mixed with a lot of water), enough to cover the whole area. (Just guess.) The more water you use the lighter your color will be; the more pigment, the darker. Test it on a piece of scrap paper if you want.

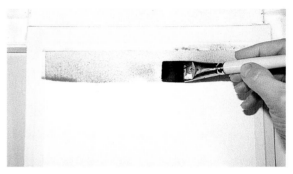

Load your brush again and make a second stroke underneath the first, overlapping them somewhat.

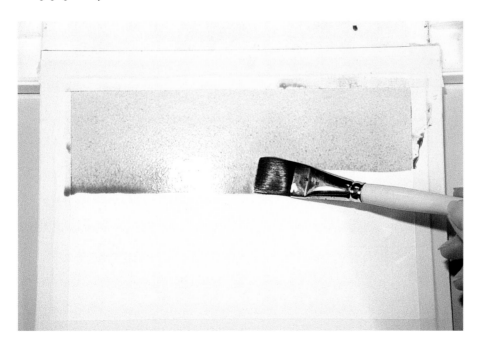

Loading your brush for each stroke, continue working downward until you reach the bottom of the paper.

56

If you have a "bead" of paint when you get to the bottom, wick it up with your damp-dry brush or a twisted corner of paper towel; otherwise, you'll have a bloom when the paper dries, which you probably won't want if you're trying for a flat wash.

Use a hair dryer if you want to speed up the drying a little.

Graded Wash

A graded wash is one that goes from dark to light. For this demonstration I dampen the paper first, this time using my sponge. I make a juicy puddle of paint on my palette and load my brush, then stroke across the top of the paper, continuing downward without reloading and removing color from the brush when I need to. If I were working on dry paper, I would add water to my brush to get things lighter instead of removing pigment.

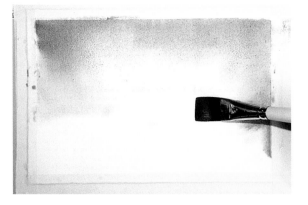

Changing Your Paper

When you're ready for a new piece of paper, carefully remove the tape from the one you're done with when it's dry. Go slowly; pull away from the paper. I sometimes reuse the tape if I can get it off without it turning into a big mess and can keep it straight, sticking it to the edge of the table or the arm of my lamp.

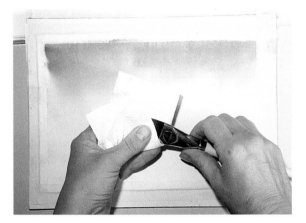

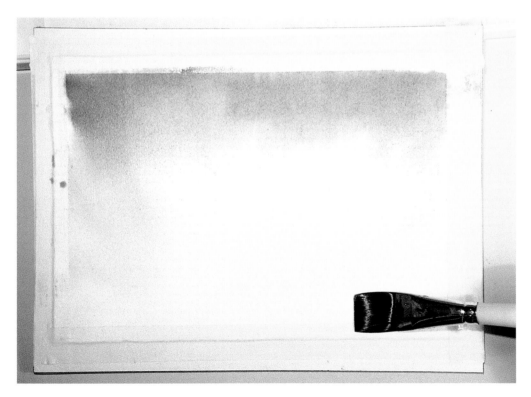

Variegated Wash

Oh, how I love doing these. I'm working on damp paper again and begin with one color, putting it right across the top, as you can see at right. Then I bring in another color, and still another. Do you see how you can begin to talk about sunsets now?

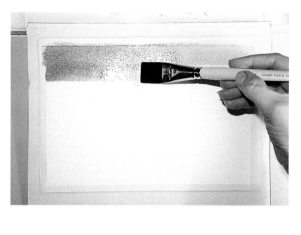

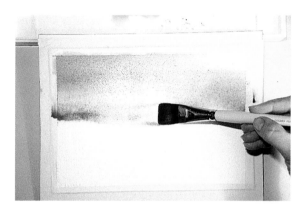

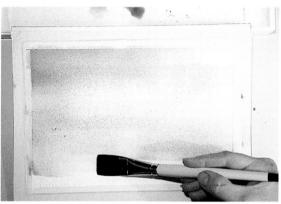

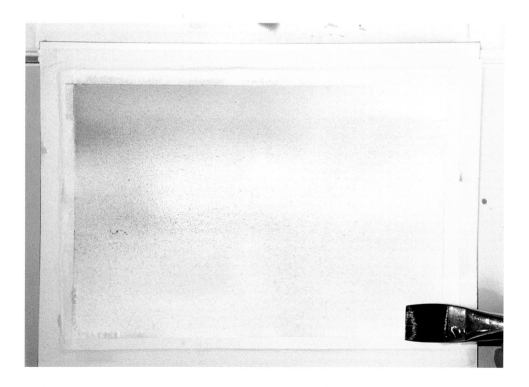

Multicolor Wash

Again on damp paper, I begin with one color (you can place it anywhere you like), then bring in another and still another.

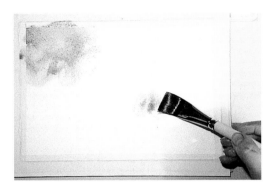

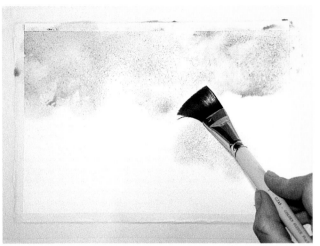

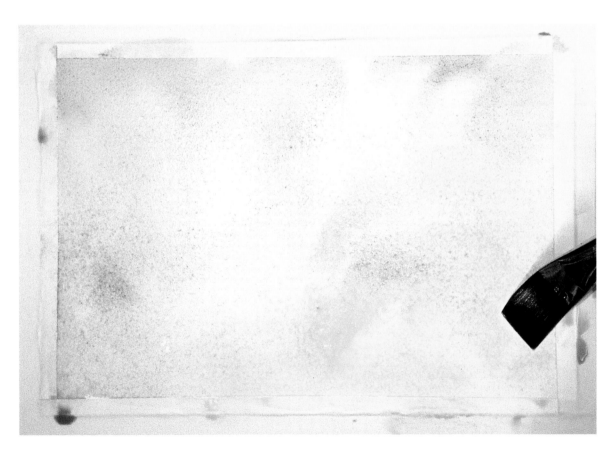

How Did It Go? Did you enjoy laying washes? Did you like doing some more than others? Doesn't the paper fairly glow through these thin veils of color?

Did you get any granulation? That's when particles of pigment settle into the "valleys" of the paper. Some colors do it a lot, others hardly at all.

Experience / Explore Glazes

A glaze is a thin layer of color applied over another one that is already dry so that the color underneath shows through. You have already experienced many ways of mixing colors: on the palette, on the paper, on the brush. Glazing is another way of mixing colors.

You can glaze one layer over another as soon as the first layer is dry, or you can put it down a year later. You can put many veils of color over one another. Entire paintings can be built up glazing layer upon layer, or you can apply a glaze to just a specific area to warm it up or tone it down. Some pigments are more transparent than others; those that are more opaque create a heavier veil.

Mix some thin, watery colors and put them over the washes you've done that are already dry. Try it in a linear, rational way, and in a playful, intuitive way. Make notes if you like. Have fun! See what happens.

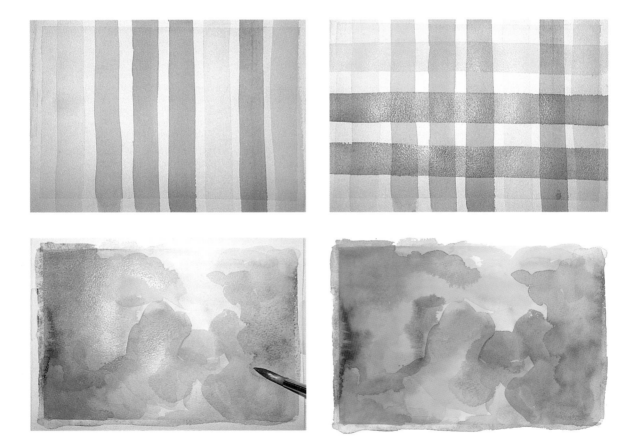

What about glazing over one of your primary-color "dances?"

How Did It Go? Did glazing resonate with you? Are you amazed at the colors that just "happened?" Take some time to be with what you've done and let the beautiful, subtle transparencies sink in. Let your soul feast. Then play with your corners to isolate little areas and look at the amazing colors; use your magnifying glass to look at them, too.

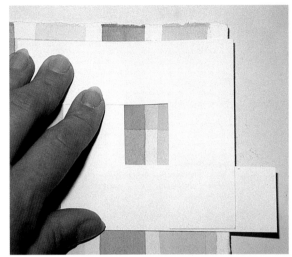

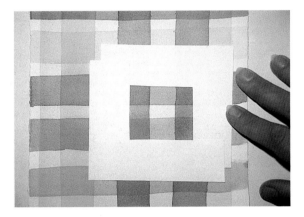

Emptying Paint Tubes

When you're near the end of a tube of paint, squeeze out as much as you can, then use a pair of pliers to squeeze out what's left. You'll be amazed how much paint was still in what you would have sworn was an "empty" tube. You can use a toothpick to get out the last bit.

A Little Painting

At any point now, if something calls to you and you think, "Hey, maybe I could paint that," go ahead! Have fun speaking your new language and seeing what happens. Accept whatever you do, and then applaud yourself! Feel free to paint right over some of your wash explorations, or use the other side of the paper.

If you see greeting cards, postcards, photographs, or illustrations that inspire you and seem approachable, have a go at copying them. Copying is a time-honored way of learning; you're simply asking another person who's created something you resonate with to be your teacher for a while. The point is not to make an exact copy but to have and enjoy the experience. Here are a few examples from some of my students.

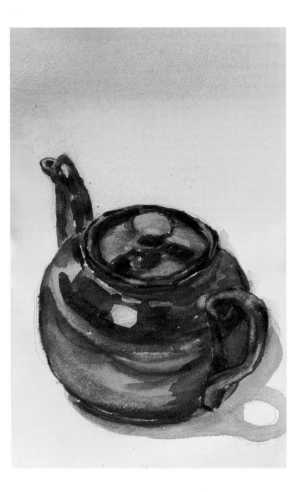

Erika painted a teapot over a graded wash she'd done in class.

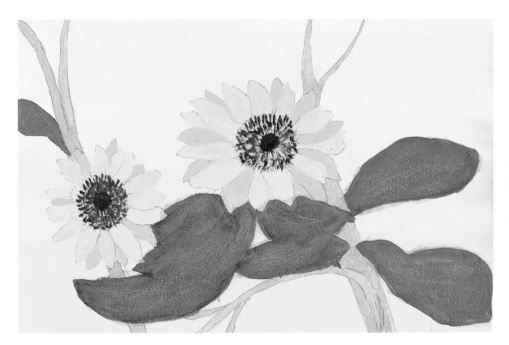

Katherine was inspired by a photograph to paint some sunflowers . . .

65

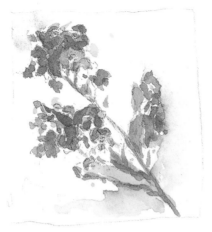

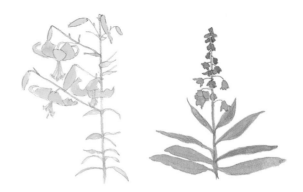

. . . and by illustrations in a nursery catalog to do these other flower paintings (above).

We inspire one another, too; touched by some little studies of forget-me-nots Betsey brought to class one day (left), Linda went home and did her own (below).

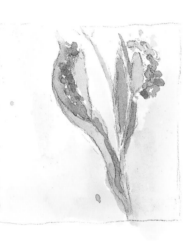

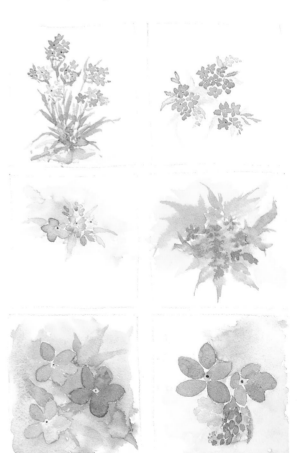

Spending Time

A while ago a friend stopped by with her daughter to bring me some plants. She had many things to accomplish that day, and when her daughter asked if she could see my house, my friend said, "Not today. We don't have time." As they drove away, those words echoed in my mind. I had been doing a lot of work with affirmations, repeating positive phrases over and over to effect a constructive change in thinking, and had begun to see how the words we say and hear all play a part in creating our reality. The ways we speak about time make it sound as if we have no control over what we are doing. But in fact, we choose what we want to do with every moment of our life, consciously or unconsciously. My friend had the time if she wanted to take it; she simply had other priorities she wanted to spend it on that day. Hear the difference? In the first way it's happening to her; in the second, she's doing the choosing.

Only recently have we become aware of how important to our well-being it is to take care of ourselves. In this sense, being "selfish," "self-centered"—in other words, centered in oneself—means that we are no more, and no less, important than anyone else. If we take care of ourselves, we are happier, healthier human beings who are then better able to care for others. Letting our loved ones know when we need their help in taking time for ourselves gives them a chance to participate in our happiness.

The religious writer and poet Thomas Merton (1915–1968) wrote that when we succumb to busyness and overwork, we actually give birth to a subtle form of violence that destroys our own inner capacity for peace and the fruitfulness of our own work, because it kills the root of inner wisdom that makes work fruitful. But when we slow down, even the most mundane task can become an enjoyable meditation.

We create time, so of course we have it! We need to learn how to take it and spend it, which means shifting priorities. Doing something for the pure joy of it, free from judgment or expectation, is a wonderful way of healing and connecting with yourself and your world on a deep level. It is as revitalizing a form of meditation as any. I have heard it said, "In healing yourself, you heal the world." That doesn't sound selfish to me.

Artists don't save time, they spend it. Be an artist. Spend time.

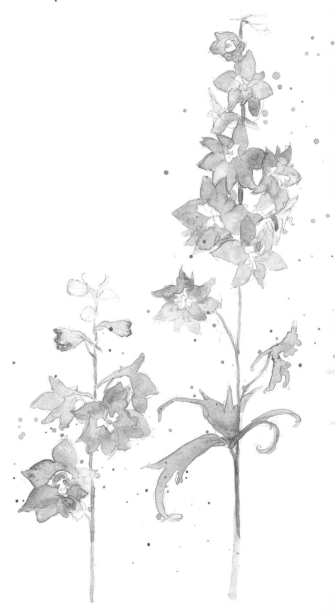

THE WONDERFUL WORLD OF NEUTRALS

Now we're going to explore the neutral colors. What are "neutrals?" What may be seen at first as dull, unexciting browns and grays is actually a world of extraordinary, subtle beauty.

A neutral color is one that contains all three primaries, and happens when you mix any color with its complement—the color that lies directly across from it on the color wheel. Red and green are complementary colors; so are yellow and violet, and blue and orange. (More about complements in a bit.)

SOME NEUTRAL
COLOR MIXTURES.

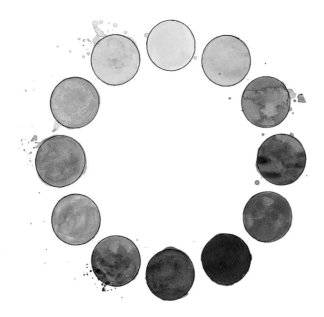

Experience / Explore Neutral Colors

Let's spend some time exploring these colors, mixing them in both 1) a linear, rational way and 2) a playful, intuitive way. For these exercises, you will need six or more ⅛ sheets of paper, which you'll work on dry. You can choose whichever pair of complements you'd like to experiment with first; the sequence is up to you:

- red + green
- yellow + violet
- orange + blue

Linear Color Play

This exercise is just like what you did earlier in mixing the secondary colors, except this time you'll be combining a secondary color with the remaining primary, or vice versa.

Mix up a big puddle of two primary colors to get your secondary, and bit by bit, bring in (mix toward) the third primary. Here, I've mixed yellow with red to get orange; I'll add gradual amounts of its complement, blue, to create a range of neutrals. As each new color appears, I save a little patch of it on my paper.

I begin with orange.

Then bring in a touch of blue.

Notice how the character of the orange has completely changed. It has been neutralized ever so slightly by its complement and is a very different color now, with a completely different feeling.

There's something about putting each color down separately—each so closely related and yet so different—that fills me with awe! Notice how the neutrals can vary in coolness and warmth according to the proportion of one color to the other in the mixture.

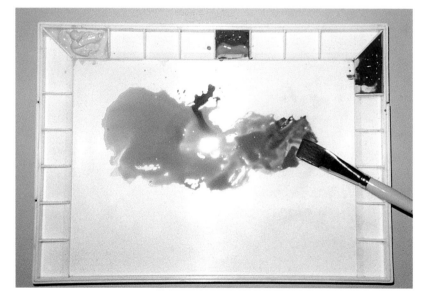

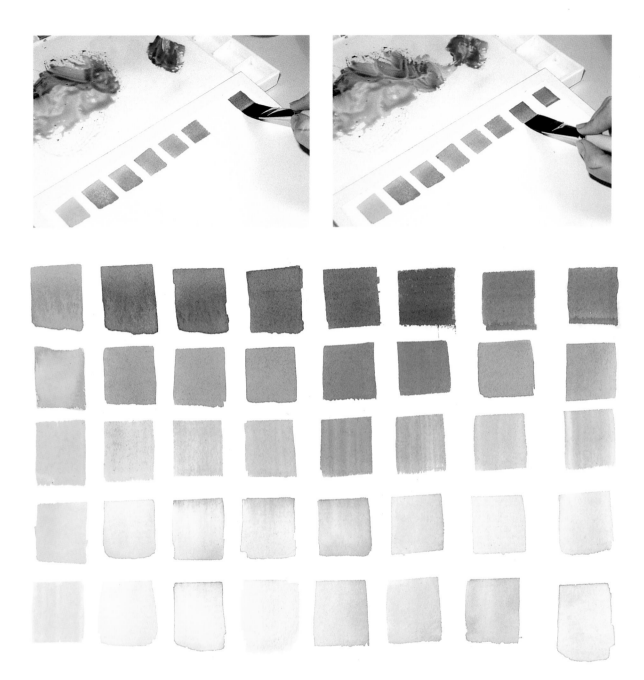

In addition to creating neutral colors, we can also "neutralize" any color—tone it down, soften it, warm up a cool color, cool down a warm color—by adding just a touch of its complement (or the third primary).

Just have fun with your colors and see what happens. You are exploring new territory. Enjoy the trip. While you're playing and when you're finished, take some time to look at these incredible colors you've created. Aren't they beautiful? Aren't you amazed?

Shown on the facing page are my explorations of the complementary pairs red plus green and yellow plus violet.

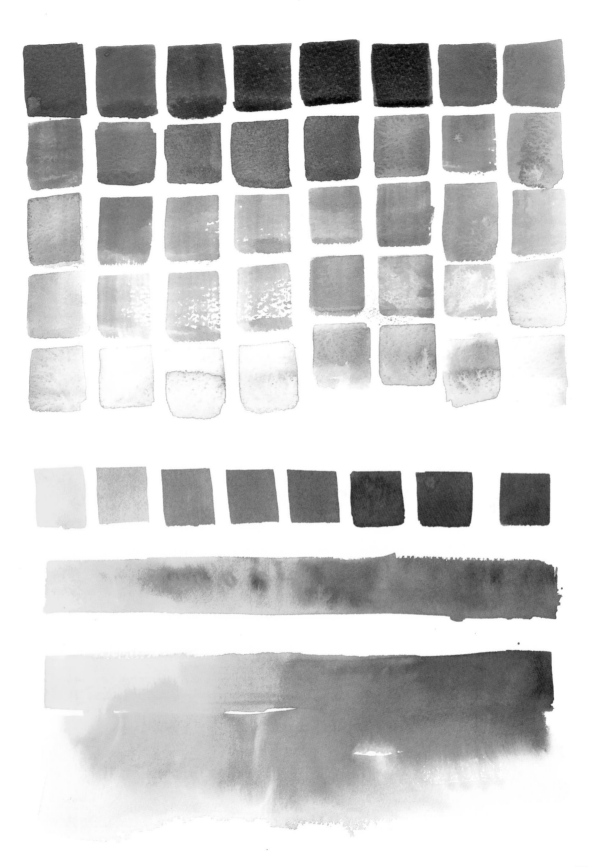

Intuitive Color Play

In this demonstration I use the same pair of complements, orange and blue. Play with the wonderful colors you've been making, using your round or flat brush or both and working on dry paper, adding water whenever you wish to see what happens. I even try my spray bottle when I'm nearly done.

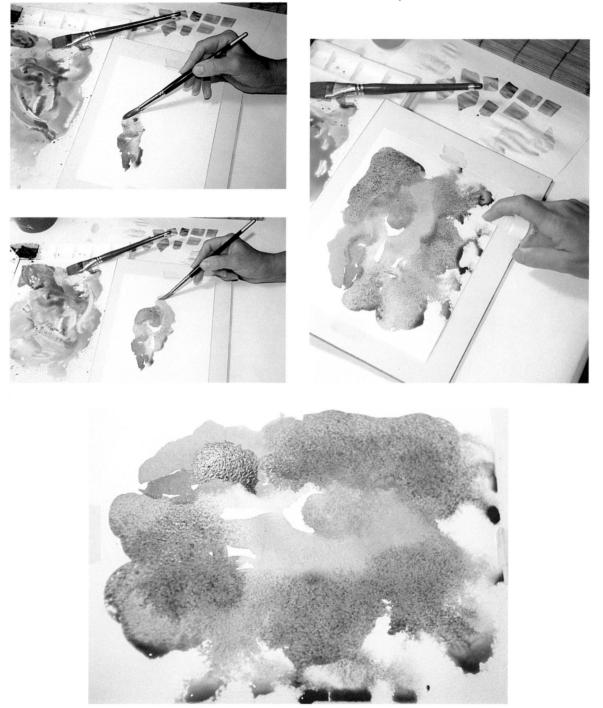

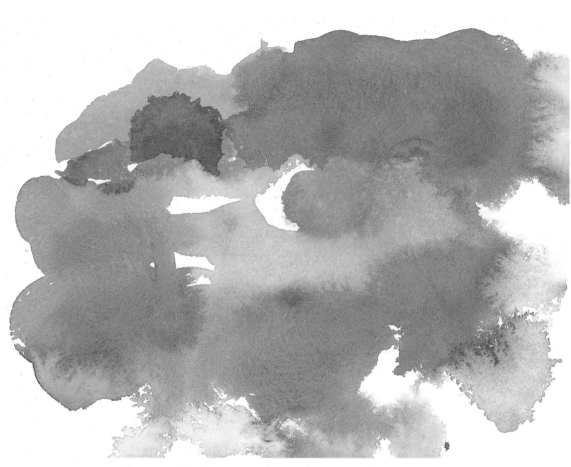

See how much lighter it is when it dries than when it was wet?

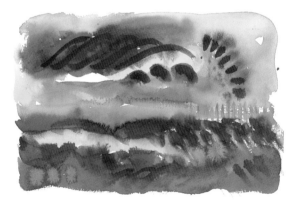

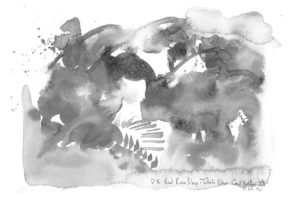

Here are the intuitive combinations I made with the complementary pairs red and green, and with yellow and violet. You've got the idea, so close the book and go have fun!

How Did It Go? Up until the time you did this, you may not have believed that it was possible to make so many colors. Don't you feel rich for having made them? Did you have any noticeable resonance with certain colors? Which ones? Your personal color sense is continuing to deepen.

Put your neutral-color explorations up on the wall and look at them all together. Get out your secondary mixes, too, and look at them together. All these colors from three tubes of paint! Don't they look beautiful?

Have you begun to notice yet that you're seeing colors differently when you're out in the world, as if someone turned up the lights? You are developing your color sensitivity, your color vision. It is happening naturally, without effort, simply as a result of your play and exploration.

Here are some more neutral explorations, one by Mary (right), the other by Katherine (below).

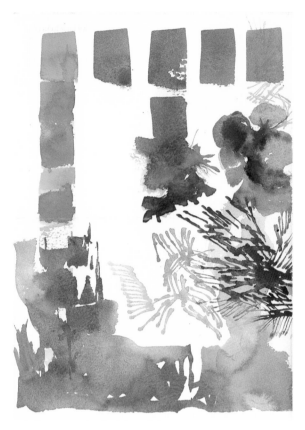

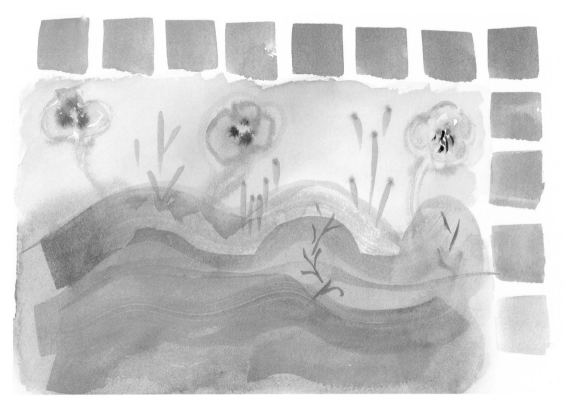

Experience / Explore the Color Wheel, Part II

Add some neutrals to your color wheel. Mix each pair of complementary colors and place the results on the inner ring of the wheel. For any given complementary pair, you will create two different neutrals, according to the proportions of the colors in your mixture. For example, when you combine orange with blue, use more orange and less blue near the orange, and more blue with less orange near the blue.

Here are a couple of color wheels Linda did.

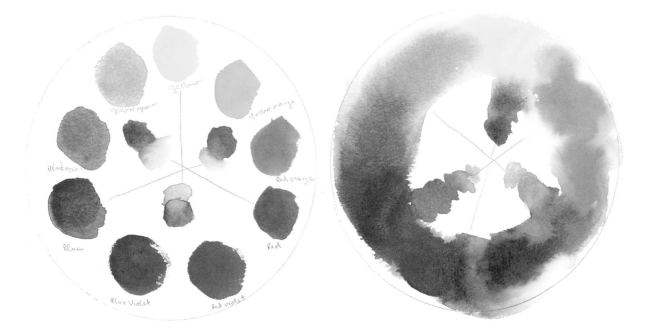

Color Theory Review

Let's review what you've learned so far about the various aspects of color theory, and introduce a few new terms.

Hue: The name of a color—blue, pink, orange, and so on.

Primary colors: These are red, yellow, and blue; they are called primaries because they cannot be mixed from other colors.

Secondary colors: These are created from equal mixtures of two primaries; they are green, orange, and violet.

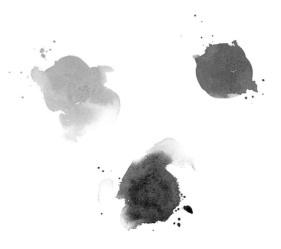

Tertiary colors: These are created by mixing a secondary color with its adjacent primary; they are yellow-green, red-violet, yellow-orange, blue-green, blue-violet, and red-orange.

Neutral colors: These are composed of all three primaries; another way to say it is that they are made by mixing a pair of complementary colors.

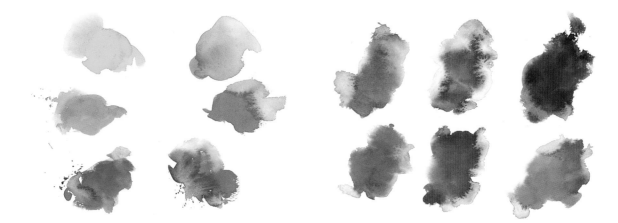

Tint: A color that has been lightened by the addition of white. In transparent watercolor, this is the white of the paper; colors are lightened by thinning them with water, which allows more white of the paper to show through.

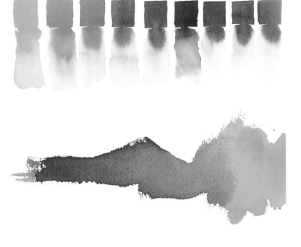

Shade: A color darkened with the addition of black or another dark hue.

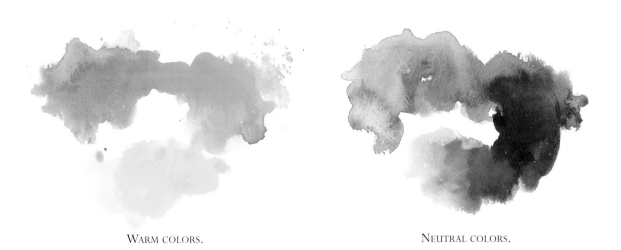

Temperature: The appearance a color has of being warm or cool because of psychological, physical, and emotional associations. *Warm colors*—the colors of fire, blood, the sun, a blushing face—are reds, oranges, and yellows. In a painting they usually appear to advance toward us. *Cool colors*—the colors of ice, water, the sky, a cold body—are blues, greens, and violets. They usually appear to recede from us in a painting. Neutral colors—browns, grays, blacks, and whites—are neither warm nor cool, and appear to lie somewhere in the middle.

COOL COLORS.

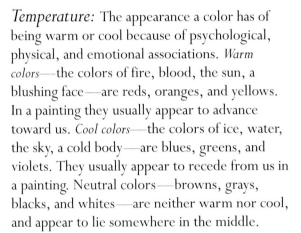

WARM COLORS.

NEUTRAL COLORS.

77

The primary colors exist in both warm and cool versions. For example, lemon yellow is cool, with just a touch of blue in it so it leans toward green; cadmium yellow light is warm, with just a touch of red in it so it leans toward orange.

Red rose deep is cool, with just a touch of blue so it leans toward violet; cadmium red medium is warm, with just a touch of yellow so it leans toward orange.

Ultramarine blue has just a touch of red and leans toward violet. Is it warm or cool? How do you see it? Phthalo blue has just a touch of yellow and leans toward green. Is it warm or cool? This feels like the warmer blue to me.

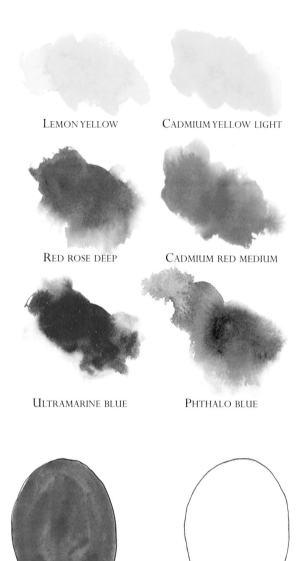

LEMON YELLOW CADMIUM YELLOW LIGHT

RED ROSE DEEP CADMIUM RED MEDIUM

ULTRAMARINE BLUE PHTHALO BLUE

Complementary colors: Those that lie opposite each other on the color wheel (see pages 68 and 75); for example, green and red, violet and yellow, and orange and blue are pairs of complements. "Complement" has the same root as "complete." When you add a touch of, say, red to a mostly green painting, you experience a subtle sense of completeness, because now "all" the colors are there. The brain actually seeks the complement of a color. See for yourself: Stare at the red oval at right for thirty seconds, and then at the white one. Did you see a green oval, or afterimage? If not, try letting your eyes go out of focus while you stare.

Analogous colors: This term refers to colors that are next to or near each other on the color wheel. At right are some examples:

- red, red-violet, and violet
- yellow, yellow-green, and green
- yellow-orange, orange, and red

Value: The relative lightness or darkness of a color. Imagine a black-and-white photograph, in which colors are represented by a range of grays that lie between black, the darkest dark, and white, the lightest light. It's the different values of the colors that make them distinguishable from one another. (We'll study value in more depth a little later on.) In the illustration at right, the orange at left is of a lighter value than the one next to it.

Intensity: This term describes a color's brightness. Imagine a red bulb on a dimmer switch turned down to low intensity, then up to high intensity. Color straight out of the tube is about as intense as it gets. In painting, intense colors usually appear to come toward us, and less intense colors appear to recede. In the illustration at right, the red at left is very intense, while the one next to it is less intense; it is muted, softer. It has been neutralized by the addition of a touch of green.

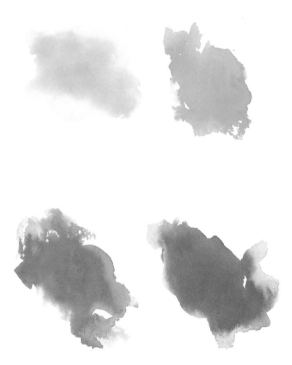

That's basically it. There is more, of course, and as you keep painting, playing, and studying, you'll learn whatever you need to know. Let all this be interesting in an informative sort of way. Let yourself be guided primarily by your intuition, by what feels right to you. Color is the language of the emotions. *Your* emotions. As you use different colors, listen for your response. The world of color is big and it is different for everyone. You are finding your own way of speaking this language with every stroke of your paintbrush.

THE DEEP, DARK WORLD OF BLACK

While you've been exploring this wonderful stuff, you have been learning a great deal on an intuitive level about painting technique, color mixing, and color theory. All of these possibilities are now available to you as you learn to speak in your own personal way about what you see, as you begin to paint your life.

Now let's take a peek into the deep, dark world of black. There are different blacks in tubes—lamp black, ivory black, Mars black—and limitless combinations of dark pigments that will yield blacks.

It's been my experience that people who paint a lot in watercolor like the life and variety in blacks (also called darks or darkest darks) that they mix. I know I do. Even when I'm doing value studies, I usually mix my dark simply because I don't have a tube of black paint handy, and I like the way the different pigments settle uniquely every time. Of course, there's nothing wrong with using black pigment from a tube; you may even prefer it. Try it in combination with other colors, say a touch of red rose deep or viridian green to see what happens. Sounds rich, doesn't it?

If the idea of painting so much darkness is positively yucky, do it anyway! Open the door. See what it's like to create and speak with black, with dark.

Experience / Explore Mixing Darks

Once again, we'll mix and create colors in 1) a linear way and 2) a playful, intuitive way. For this first exercise you will need two or more pieces of paper, which you'll work on dry as you have fun exploring black and grays. Add your dark brown paint to your palette and explore:

• blue + brown = black (or dark)

Linear Color Play

Begin with either brown or blue, proceeding just as you have in previous linear color exercises. As you progress from one color to the other, black or dark-gray midtones will occur in the middle. If you use a lot of pigment, you'll create a black. On either side there will be different grays, which will be cooler when there is more blue in the mixture and warmer when there is more brown. They will be lighter or darker depending on the ratio of water to pigment. More pigment, less water, darker; more water, less pigment, lighter. If your black doesn't come out exactly "black," don't worry. The main point is to get it *dark*. If you want to get it darker, what might you do?

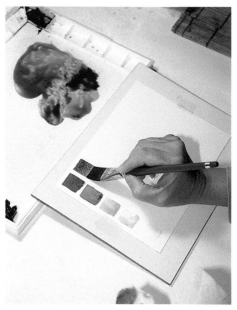

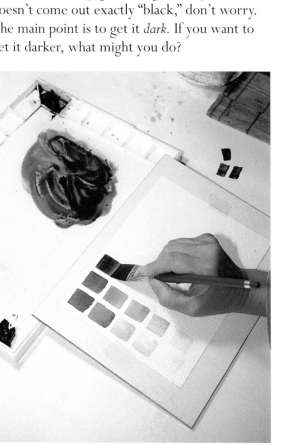

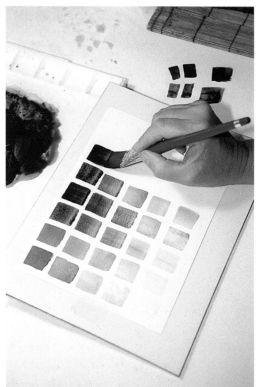

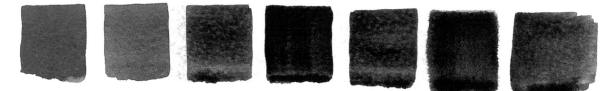

Intuitive Color Play

Have fun letting your brush dance and play.
Ready? OK, go!

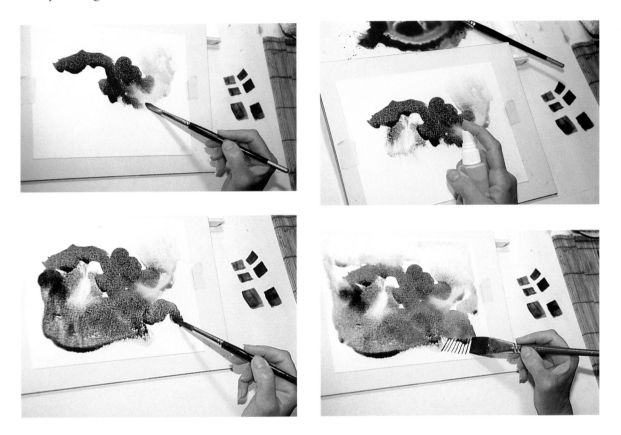

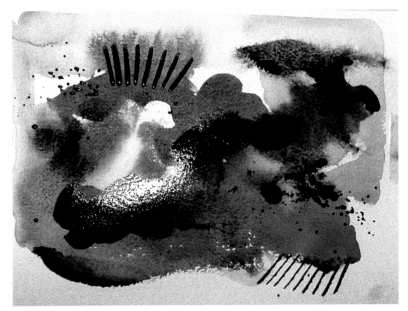

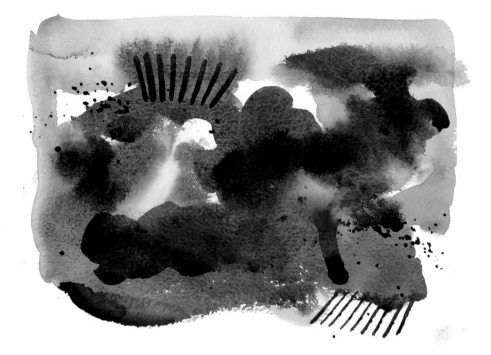

How Did It Go? Who would have thought there would be so much subtle variety in blacks and grays? It is spellbinding, is it not?

Below is an exploration Betsey did using French ultramarine blue and sepia to get a range of darks.

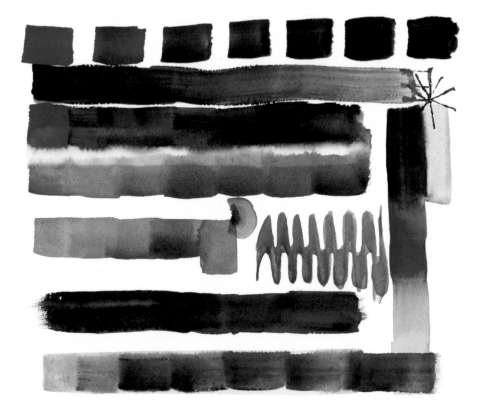

Experience / Explore Dark and Light

Placing these darkest darks next to our lights sets up a contrast that can really make the lights glow. If you want to say "light," one sure way is to put some dark next to it.

Now let's explore traveling from the darkest dark to the lightest light—creating the many grays that can exist between black and white—in both linear and intuitive ways. You'll need two or more pieces of paper for this.

Linear Color Play

Mix up a nice big puddle of black or "dark" and go from darkest dark to lightest light. Remember, in transparent watercolor, our white comes from the paper, so lightening a color means using more water with it.

Here is one way to approach the exercise:

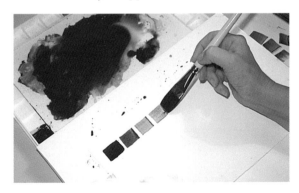

And another way:

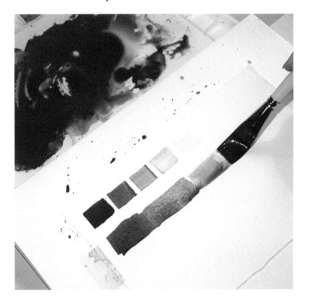

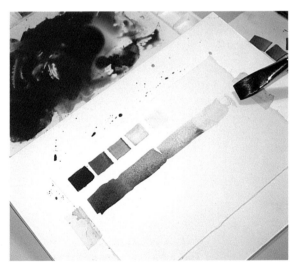

And still another way:

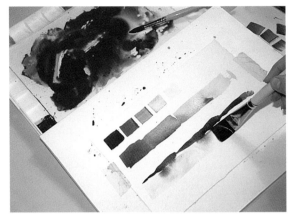

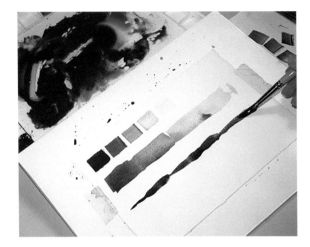

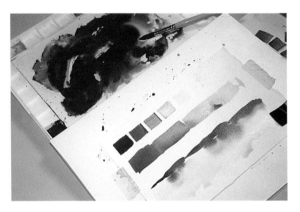

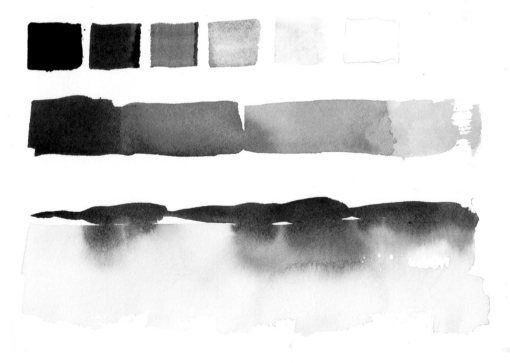

Intuitive Color Play

Using any brush you like, go have fun with
black. In this demonstration I'm using my round
and flat brushes, adding water along the edges
to see what tints I can create.

How Did It Go? What did you think and feel about black before you did these exercises? How do you feel about "black" now? Did you find your thoughts deepening? Did you perhaps feel any sensations of strength and power? Was the idea of exploring, painting, "speaking" black—spending time with all this dark, strong stuff—unappealing? Maybe even uncomfortable? Any surprises? Did you skip it altogether?

Take a closer look at what you've done using your mats, corners, and a magnifying glass. Your paintings have much to teach you; spend time with them, looking, relaxing, not thinking; taking them in, soaking them up.

More Fun: Brush Play

Take a few sheets of bond paper (or even the plain backs of junk mail) and try out your rigger. Begin to see what marks you make. It is such a fun brush, giving delicate, almost effortless lines, seeming to go forever without needing to be refilled. Play some more with your round brush, too, and anything else that comes to mind. Here's some of my brush play.

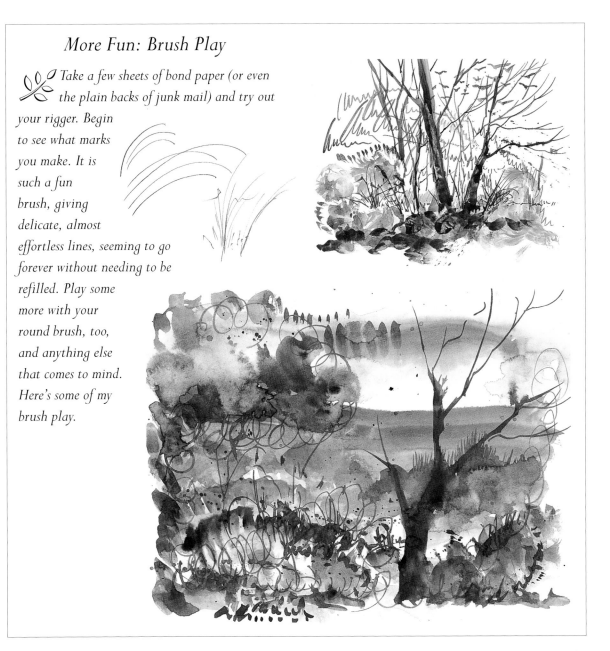

87

NOW, ABOUT DRAWING . . .

By now I bet you're feeling pretty comfortable playing around with your paints and brushes. Now, about drawing. Drawing—the act of recording and expressing your life energy and experience of the world in line and tone—is (supposed to be) as natural as singing and dancing and more basic than reading and writing.

If you think you can't draw, play your way through this chapter. By the time you reach the end, you'll feel differently, I'm sure.

Experience / Explore Making Your Marks

Can you remember a time when you loved to draw—before you began to get upset if something you drew didn't look "right," before it had to look like anything at all? Just as you played with color in the beginning, I'd like you to begin today by playing with line, letting your arm and hand move freely across the paper. Yes, scribble!

You'll need three sheets of 8½ x 11" or larger bond paper and four or five pencils (old stubby ones are fine). A timer is handy, too.

• First, with pencil in hand, have fun making your marks. Here are some examples.

- Next, see what marks your other hand wants to make. It hardly ever gets a chance to play on its own, much less say something. Do this for three minutes.

- If you've been sitting for the first two exercises, this time *stand as you draw,* because your arm can move more freely from the shoulder when you're standing. This is especially fun to do on larger paper, if you have some. See how it feels. Make your marks for three minutes. Don't think; just let your arm move.

Once again, this way of letting go may feel a little scary. Just picking up a pencil for something other than writing might trigger old fears. It's OK. You're safe. For the next few minutes, scribble to your heart's content. You are awakening and strengthening a connection that has been long dormant. The connection between your heart and hand is temporarily freed from the mind.

How Did It Go? When you're done, tape what you did up on the wall and have a look at these wild and crazy marks you made! Each mark is a record of your energy at that particular moment in time made visible. Isn't it amazing when you think about it in this way? How did it feel making marks with your other hand? Awkward? Uncomfortable? How did it feel making marks standing up? Did you feel bigger movements begin to happen? Do you feel a little energized?

Making your marks often is great for keeping your inner connection open and for loosening up if you're feeling a little tense. It's also fun to do with others; then everyone can see how very different (and sometimes very similar) their marks are.

Drawing Your Connection to the World

Now, choose a natural object—a leaf, a flower, a pinecone—and focus your eye on a point along its edge. Take a few deep breaths. Relax. Imagine that your pencil is connected to the point you are focused on, and as you begin to move your eye along the edge, move your pencil slowly along the paper. Don't worry about what's happening on the paper. The idea here is not to get the image to resemble what you're looking at, but rather, to feel your connection to it. Relax. Go very slowly. Give yourself about ten minutes for this.

Here are a few drawings to help you get the idea. On this page are a dandelion leaf (top) and some balsam branches; opposite at far right is a pinecone (the flower drawing is Betsey's); and on page 94 are two drawings of a branch of bittersweet (top) and one of a fern.

How Did It Go? How was your experience? Do you feel any different about things? About drawing? Do you feel relaxed? Did you find it difficult to go slowly?

And these marks. Aren't they extraordinary? They speak directly of the essence of your subject, don't they? These marks are records of your energy connecting with "the other"—becoming one.

"In drawing, there is always the sense that if you can just look closely enough . . . some secret is going to be revealed to you, some insight into the nature of things in the world. Learning through drawing, therefore, can fill a lifetime, since such secrets lie at the bottom of a bottomless well, and the searcher never wishes the search to end."

—Betty Edwards, Drawing on the Artist Within

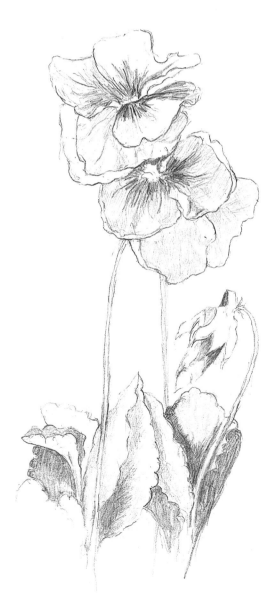

"I have learned that what I have not drawn I have never really seen, and that when I start drawing an ordinary thing I realize how extraordinary it is, sheer miracle: the branching of a tree, the structure of a dandelion's seed puff. . . . I discover that among The Ten Thousand Things there is no ordinary thing. All that is, is worthy of being seen, of being drawn."

—Frederick Franck, The Zen of Seeing

Experience / Explore Drawing What You See

Draw your connection again, this time looking at your paper now and then to see what's happening. Yes, you can peek!

Let whatever words come to mind resemble these: "This goes this far before it bends. This is a little wider here. This line leans to the left like this . . . hmm, even more. This curves around, like so." Erase whenever you need to.

Be easy with yourself. Don't hurry. Relax. Here are some of Katherine's drawings.

How Did It Go? You're drawing—experiencing your connection to the world and recording it on paper. Does it feel like the meditation it's supposed to be? Once we get the incessant judging out of the process, it truly becomes a meditation, doesn't it?

Do some more. And if you feel like splashing a little watercolor on any of them, go for it!

At this point, if you feel like taking a break from the book for a while, go ahead. Keep playing, drawing, splashing paint onto paper. If you don't have a sketchbook yet, get one and fill it up. Have fun! When you're ready for more, come on back.

Experience / Explore Seeing and Drawing Shapes

Now let's spend some time looking at and then drawing a subject by forgetting about what it *is* (here, a pear) and trying to see it instead as a series of simple shapes.

- Look at the photograph of the pear shown here, then at the black-and-white photocopy of it.
- Find any shape in the photo or copy. Pretend you're looking at a puzzle and this is a piece of it.
- Let your eyes relax; soon you should be able to see the shape. Ever look for animal shapes in the clouds? It's kind of like that.
- Once you can see the shape as a puzzle piece, draw it. Then go on to the next, then the next.
- Erase whenever you need to.

Here are some examples by three of my students, with my own at far right. Note how differently everyone saw the shapes.

About Erasing

More than once as I was growing up, I heard this admonishment: "Don't erase. Real artists don't erase, they just leave their marks." It stopped my clock for quite a while, shut me right down.

I say, erase all you want! In the beginning, you *have* to. A mistake doesn't mean you've done something wrong; it means you're seeing something more clearly. You have to start somewhere, and it has to be where you are. After a while, you might see it differently. Leaving lots of marks would be confusing at this stage, and you probably don't want a trace of your earlier effort to show anyway. So go ahead and erase them! I bet you a box of Magic Rubs that every artist, however renowned, erases whenever he or she feels like it.

If you want to make something darker in watercolor, you add more pigment; if you want to make something lighter, you just add more water, or wipe it out altogether with your sponge or scrubber. If you want to make something darker in a pencil drawing, you press harder or use a softer pencil; if you want it lighter you use lighter pressure or a harder pencil; and if you want to lighten an area or wipe something out altogether, you use an eraser—anytime! Do whatever you need to do to say what you're trying to say. Sometimes it takes a while to find out what that is—and that's supposed to be part of the fun!

Many times an art teacher will ask students to let the gesture carry them through and let the marks stand—in other words, no erasing. This is a great way to push past resistance and do some exciting, strong drawing. But it can be unfortunate if you don't understand that it's just

for now, for fun, to have the experience. If you get the message that there's something wrong with erasing, you will no longer feel you have the power over your own paper and won't want to draw much. The pressure of getting it right the first time is just too great. So go ahead—erase all you want. It's *your* paper!

Drawing in a Nutshell

- *Take the time you need.*

- *Draw the shapes you see.*

- *Draw lightly so you can erase easily while you're searching. Dark lines are for when you're more sure of things and/or want to speak strongly. And you can always make a light line darker.*

- *You don't have to record everything you see.*

- *If you want to put in details, do it toward the end.*

EXPLORING THE WORLD IN SERIES

One of my favorite ways to go about painting is by working—playing—in a series, which can mean depicting a specific subject as many times as you like. It's just a matter of exploring different ideas and possibilities as they occur while you are painting, and giving yourself new fields—pieces of paper—for each new adventure.

Choose a piece of fruit or a vegetable that you have on hand, or go to the market to buy something. Do work from a living fruit or vegetable rather than an artificial one, because it's a very different experience. It's life that has been calling you to paint it, to express its wonderful mystery through you.

I'd like to show you a couple of possibly helpful things before the exercise; the first is a way of drawing in preparation for painting.

Drawing for Painting

When you're drawing for painting, you only need to record the main shapes you see—the shapes of the form(s), the lights, and the darks.

Here's my subject, a pear; I love pears. I suggest lighting it so you have one single, strong shadow you can see clearly; a spring-arm or flexible-neck desk lamp works great for this. Don't worry about the background at this point.

Take time to "be" with your subject. It's a way to help you shift from going lickety-split-getting-everything-done to slowing down and feeling centered inside yourself.

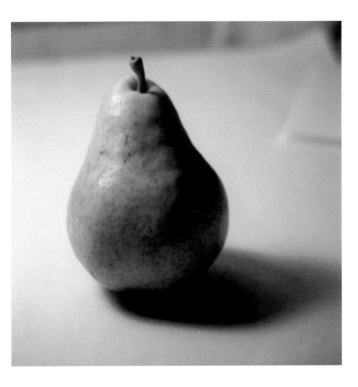

I use a viewfinder to help me frame my picture.

I draw with my fingertip to imagine how the pear will look on the paper.

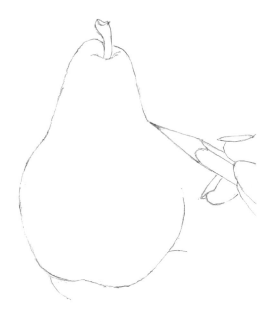

What is the shape of the form? It looks like this to me. I happened to start at the top this time, continuing down the left side; start wherever you want.

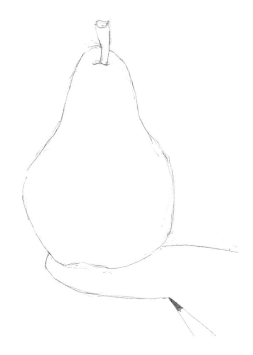

What is the shape of the shadow the pear casts on the table? I see a shape something like this. I'm seeing the shapes of the spaces where the cast shadow leaves the form, letting the shadow run right off the paper, not stopping just because the paper stops.

Now, what is the shape of the shadow on the pear itself? This is called the form shadow. I squint (simulated by the out-of-focus photo) to see it more clearly; this lets me make out an actual line where the light becomes dark, where the shadow begins. This is the edge of the shadow shape. You squint too. Do you see it?

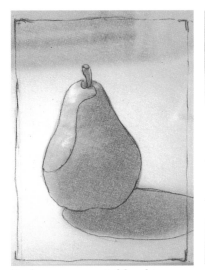

Perhaps you see it like this or like this.

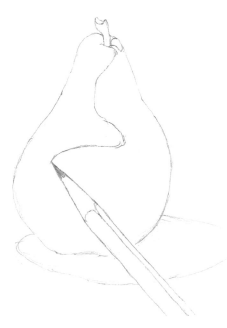

I draw the line I see about like this. I also see the stem shadow and space as shapes, and draw them, too. You can change what you see by the amount you squint. Try it one way now, another way next time. That's it!

I'm going to say the rest with watercolor. Wait! As I squint I see a couple of highlights. They would be fun to talk about, too. They'd really say light! I see the shape sort of like this.

Now, to dance the colors down.

Experience / Explore a Pear in a Series

I let my hand reach for the colors I want and dance them onto the paper. I'm not thinking about making a painting. I am recording my experience and playing with watercolors, and though I'm putting my process into words here, it's really wordless.

Now I let the painting dry, and in the meantime I begin another one.

I do essentially the same drawing again; it goes a little more quickly this time. I wonder how it would be if I wet the pear first? Let's find out. I paint it with water . . .

. . . then dance in my color.

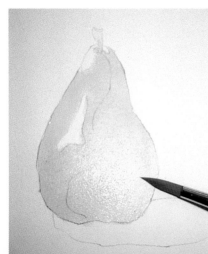

I decide to let this one dry before going any further, so I set it aside.

101

I go back to my first pear painting, which is dry now (see previous page). What next? The form shadow. It's darker and cooler than the pear itself. How might I talk about that? Blue is cooler, darker, too. I try it to see what happens. Since I'm not making a painting there's no way I can ruin it. I'm simply exploring. The cast shadow is dark and cool as well, so I try blue there too.

There. I set this piece aside for now.

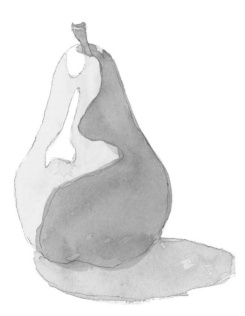

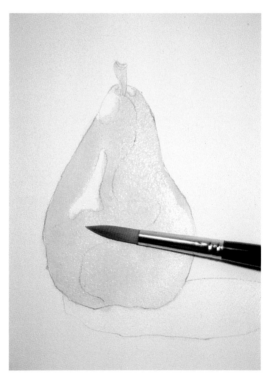

I go back to the second pear painting I started. This time I want a softer effect. Softer always means water, in one way or another. I could use water before or after I put my color down; here I do it before, rewetting the entire pear and painting with water (except for the highlight, because I don't want any color to go there).

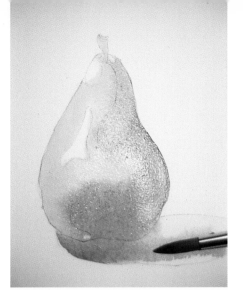

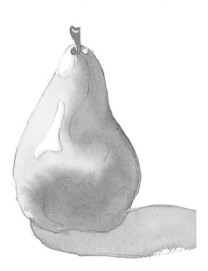

Then I drop in my blue while it's still wet and see what happens. I go right into the cast shadow, too.

That was fun. I loved having the pear wet that time, dropping the color into the water. Here's how it looks when it dried.

I try another one, wetting the pear first again, then dropping in my color.

This time, I drop in the shadow color right away while the surface is still wet, again bringing it right out into the cast shadow.

I lost that little indentation in the middle of the shadow shape. What might I do to get it back? I want to take the color back up. It's still wet, so I grab a paper towel and dab it. It works.

Now it's a little whiter than I want; I'd like some yellow-green back there. Things are still pretty wet, so I get some color and put it right in.

There's quite a puddle.
I think I'll wick some of it up.

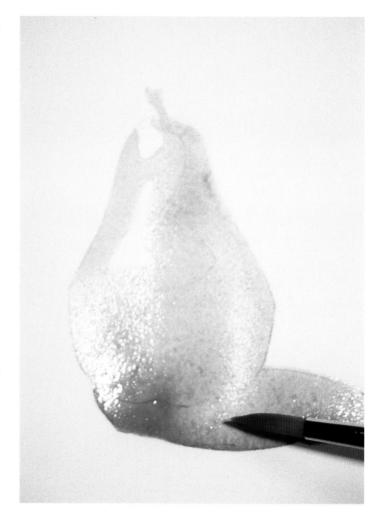

Get the idea? I'm going with what's happening, and I don't know ahead of time exactly what's going to happen, though I may begin with an idea.

Details, if there are any I want to talk about, come after I've got the basic form, color, light, and shadow (dark) down.

Here is the finished pear from the preceding sequence. It dried very light . . .

. . . and I decide to make it darker to see what happens.

I was having so much fun, I did another one.

Experience/Explore a Subject in a Series

For this exercise you'll need four to eight $\frac{1}{16}$ sheets or small pieces of paper (measuring about 7½ x 5½" each) in a pile ready to go, and a pear or other fruit or vegetable that has called to you. Light your subject as I explained a little earlier.

Begin by making a simple drawing on your paper, and use that eraser all you want. Keep your drawing as simple as possible, only because if you get very involved in it, you're probably not going to want to paint it. If that does happen, just save it for now and do another drawing.

Dance the colors down.

If you have a question, just make a decision based on what you know so far, or respond intuitively and see what happens. Ask, "How might I . . .?" and go on from there.

When you have several pieces of paper, you can explore your subject and experience your process more than once. This greatly reduces any pressure you might feel about getting it right the first time. Try it one way, then try it again differently. If you want one of your explorations to dry for a while before working further, just set it aside, grab another piece of paper, and keep painting. Remember, there is no right way anyway, just the idea you may have started with. Don't be afraid to keep going with what's happening. You don't have to get the color exactly as you see it. You can try for it whenever you want to—later on, maybe. Have fun!

How Did It Go? Did you enjoy yourself? Did you have fun with your process? Are you pleased? Amazed? What happened?

Here are two from a series Wendy did.

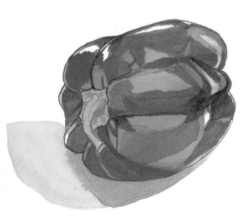

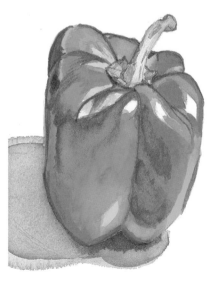

Descriptive Analysis

As you look at your paintings and appreciate that you did them, if there's anything you aren't particularly crazy about, describe what might be bothering you—for instance, "It's too cold; it's darker than I wanted; this part is popping out." Then ask, "What might I do to change it?"

Another Example: Autumn Leaves

In the fall, go out for a walk and soak in all the color. Gather some leaves here and there and bring them home to play with. Have fun describing leaves in different ways; it's not about making a painting of a leaf, it's about what happens during your experience of painting.

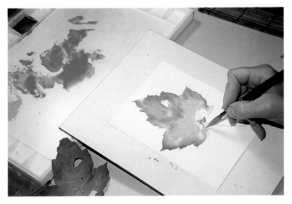

Aren't these leaves beautiful? What gorgeous color! I'm going to choose two of them to paint for another series exploration.

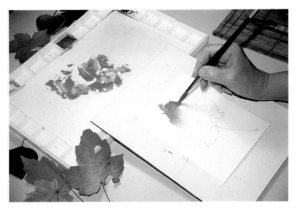

I trace around the outer contours of my first leaf, then draw the stem and put in a few of the main veins to suggest the rest. I see red, yellow, and orange blending into one another softly, so I put water down first; that way the colors can really dance together. I get some red out onto the palette and, without cleaning my brush first, pick up some yellow to "orange it up" a little.

I look at the leaf, but I don't worry about getting it exactly the way I see it. I want to have a looser, freer kind of fun with it. I decide to put a bit more red by the edges, then some more orange toward the center and some yellow in a couple of areas.

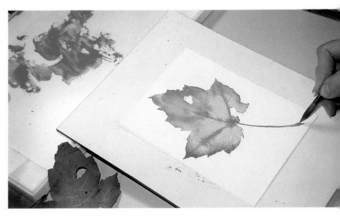

Now for the veins. They're fine lines, so I use my rigger, adding these details while my paper is still wet. I could wait until the paper is dry and get a sharper line, but I don't want to on this one. I bring the same colors right down into the stem. And now I put this painting off to the side so I won't be tempted to fuss with it.

I get another piece of paper and pick a golden yellow leaf this time.

Again I trace around its shape, then add the stem and veins. Again I begin by wetting my paper first. I mix a little red in with my yellow to try for that gold, and then put it down. Ah, magic! I add in a little more red as I work downward; see it collecting at the lower leaf points?

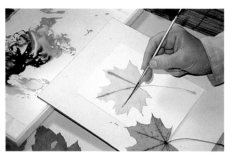

I add the veins while the paint is still wet, because on the leaf itself they look kind of fuzzy and that's what I want to capture. I mix up a brown by adding some blue into the red, orange, and yellow on my palette and, with my rigger, paint the veins. Then I dry the painting with a hair dryer . . .

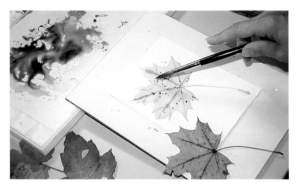

. . . and spatter on some spots.

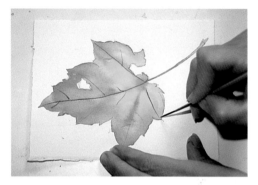

Now that my first painting is dry, I see that the soft, fuzzy vein lines dried a lot lighter than I'd anticipated, so I decide to make some darker ones . . .

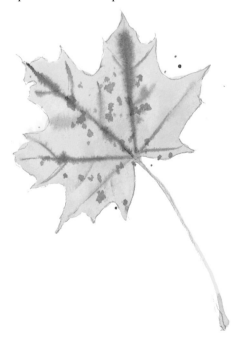

. . . and add some spatter spots.

VALUES: LIGHT AND DARK

Because of light we can see form. Where the form turns away from the light, it gets darker. Because of this we can see depth, or the third dimension. If everything is the same value, we can't see depth and things look flat.

In painting, we call the different degrees of lightness and darkness values, or tones. You have already experienced seeing them and talking about them as light shapes and shadow shapes. And, as you know now, if you want to see them more clearly, you squint.

Seeing and understanding values—relative lightness and darkness—is important if you want to create the illusion of space (depth) and three-dimensional form on a flat piece of paper and make the drawing or painting of your subject look real. It does not matter as much what colors you use as it does getting the values relatively accurate. When you can see your subject in terms of values, you can go wild with color if you want to, and it will still make sense.

Seeing Values

Look at the photo of the pear and some of the different ways to interpret it in terms of value.

I can depict it this way, in one value (here, a midtone), or . . .

. . . in two values, the light side and the dark side, with the form shadow and cast shadow depicted as one shape (enough for us to perceive the pear as a three-dimensional object);

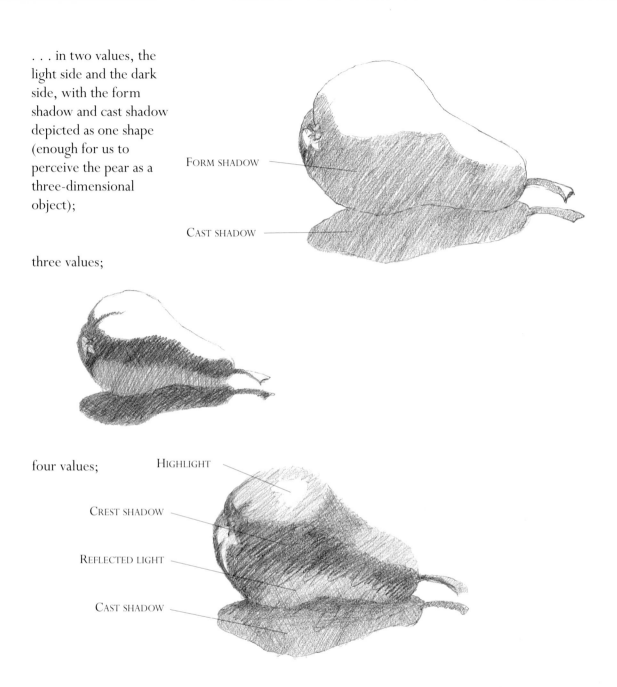

FORM SHADOW

CAST SHADOW

three values;

four values;

HIGHLIGHT

CREST SHADOW

REFLECTED LIGHT

CAST SHADOW

. . . or in five values, where I've added the darkest darks. Neat, eh? These are all *value studies* of pears.

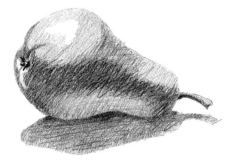

Experience / Explore Hatching and Crosshatching

On two or more sheets of bond or drawing paper, have fun making areas of tone with closely spaced parallel lines. Draw them close together, and then even closer together; with light pressure, then heavy pressure. This is called hatching. You can build up layers of hatching to create different values.

Now try crosshatching—building up tone with lines that cross your parallel hatch lines at an angle. Try different pressures and spacings.

HATCHING.

CROSSHATCHING.

How Did It Go? Did you like the feel of crosshatching? Building up layers of tone in line? Did you want to put the lines really close together so you couldn't see any white in between?

Experience/Explore a Five-Value Scale in Pencil

Remember when you went from your darkest dark to your lightest light with watercolor, making the progression in little squares or a continuous strip? Well, that was a value scale. Besides your lightest light and your darkest dark, you had light, medium, and dark midtones.

Now I'd like you to try making a value scale in pencil, building up layers of hatching and crosshatching—or shading in any way you want. Do it in layers instead of separate squares; essentially, you will be glazing with pencil tone.

To start, on a piece of bond paper or in your sketchbook, draw a long rectangle with five equal divisions, something like mine below. Then proceed as you can see in the four steps illustrated. Got it? Great.

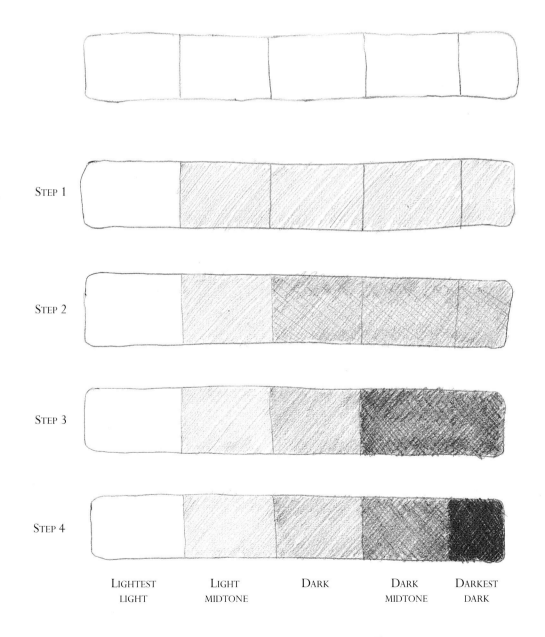

STEP 1

STEP 2

STEP 3

STEP 4

LIGHTEST LIGHT LIGHT MIDTONE DARK DARK MIDTONE DARKEST DARK

Experience/Explore Drawing a Pear in Pencil Values

Get a pear and shine a light on it. Play around, moving the light, moving the pear, watching how the shadows change. Divide a page in your sketchbook into fourths and begin talking about the light and the dark on the pear with your pencil. Start by asking yourself what you see.

- What shape is the form? Draw it.
- What shapes are the shadows? Squint. Draw their shapes.
- Is there a highlight? What shape is it? Draw it. And so on. Have fun with this!

Describe your pear by glazing in three, four, or five values with your pencil. If more than three starts to get confusing, just do three—whatever you feel comfortable with. I myself rarely use more than five values. Maybe you don't want to talk about the highlight as a separate value, or about the reflected light, speaking simply about the form shadow in just one value. Do whatever you want.

- Try this. First, hatch or shade a light midtone over everything except your lightest shape or the highlight.
- Next, crosshatch or shade (glaze) a darker tone over the shadow shapes.
- Then crosshatch or shade a darker tone over the darker shadow areas (the crest shadow; any other shadow).
- Last, put in the darkest darks and details— the stem and blossom end of the fruit.

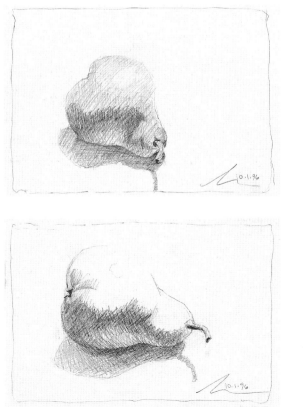

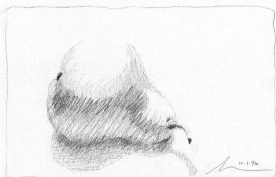

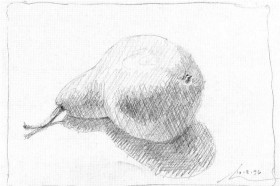

112

When you're done, move your light source to create different shadow shapes, and again, describe what you see. (If you're using the sun as your light source, you'll probably want to move the pear.) Have fun!

Building up values by glazing in tone rather than defining each value as a separate shape is particularly helpful for beginning watercolor students. Try it.

How Did It Go? Here you are, drawing again, doing value studies. Are you experiencing the magic of creating the illusion of light, and seeing the illusion of three dimensions appear on your paper when you get those shapes and values down? It always amazes me. Are you getting the hang of seeing in values and seeing shapes? If you aren't, don't worry. It will come. You're a lot closer to getting it than you were before.

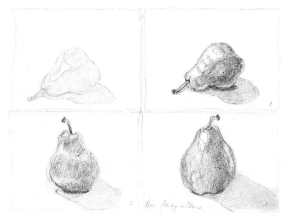

Here are some Mary did.

Experience / Explore Describing Pears Tonally in Paint

On watercolor paper, have fun doing a few small value studies using paint (your brown) instead of pencil. Paint directly from the pear if you want, or from the value studies you did in pencil.

Below are two value studies I did, and at right (top) is one of Mary's.

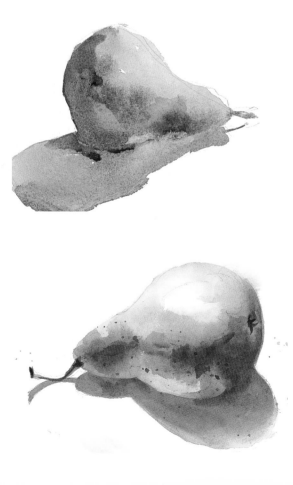

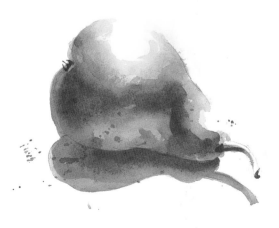

Experience / Explore Values in Color

Now have some fun talking in color, working from your pear or your value studies. Try both. If you work from your value studies, you can paint the colors that you saw, or some other colors altogether. Once you have your values you can really cut loose. As you look at your value studies, think, "How might I talk about it in color now? Red and yellow? How about yellow and green? How about pink, purple, and blue?" Why not! Get the idea? Have fun! If you have an idea and you want to try it, see what happens!

Slowing down enough to draw and paint the magic of light and dark and of color lets me truly see it and experience it, and I love it!

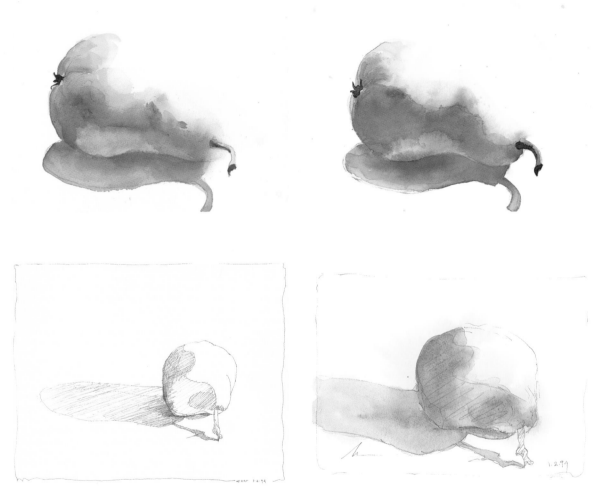

How might I describe the light and dark on this pear?

And now, how might I do it in color? This, by the way, is what I think practice is—doing something again and again because you enjoy doing it.

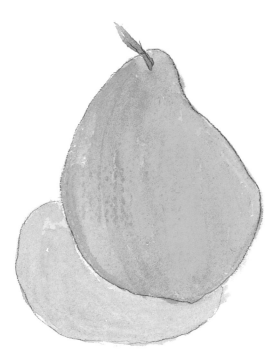

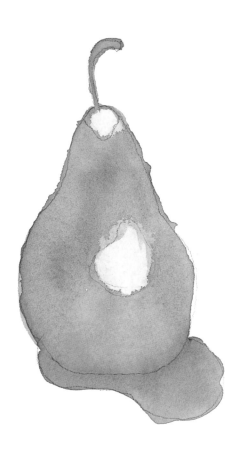

How Did It Go? Are you feeling your own process developing? I bet you're getting pretty comfortable now, exploring, seeing what happens. Isn't it fun, doing it this way? Not going for a perfect painting, but just seeing and playing, seeing some more, playing some more? And we wind up with these fascinating, wonderful tracks of our dance with life, magical records of our experience.

Here are some pears Katherine painted—one of her very first, done in the fall, and two more she did the following spring.

"*Everything you can see in Nature is seen only so far as it is lighter or darker than the things about it, or of a different color from them. . . . And if you can put on patches of colour or shade of exactly the same size, shape and gradations as those on the object and its ground, you will produce the appearance of the object and its ground. The best draughtsmen . . . could do no more than this; and you will soon be able to get some power of doing it, if you once understand the exceeding simplicity of what is to be done.*"

—*John Ruskin,* The Elements of Drawing

EDGES—LOST AND FOUND

⊘ *What are "lost" and "found" edges? A lost edge is one that has become softened to the point of disappearing; it's also known as a soft edge. A found edge (sometimes also called a sharp or hard edge) is one that hasn't gotten lost in the first place, or that, with a little coaxing, can be brought back to definition.*

A lost edge, as the name might suggest, lends a sense of mystery to things. "What happened? Where did it go?" we wonder, on a very subtle level, perhaps not even aware that we're wondering about it at all. A found edge brings things back to reality: "Ah! There you are, you rascal! I'm glad you're back."

A LOST, OR SOFT, EDGE.

A FOUND, OR HARD, EDGE.

You've already had some experience creating hard and soft edges, in an intuitive way, in your color-play explorations; they happened on their own. Remember how the edges of your brushstroke softened or disappeared altogether if the paper was wet or you added water? And how the edges stayed sharp and hard when the paper was dry?

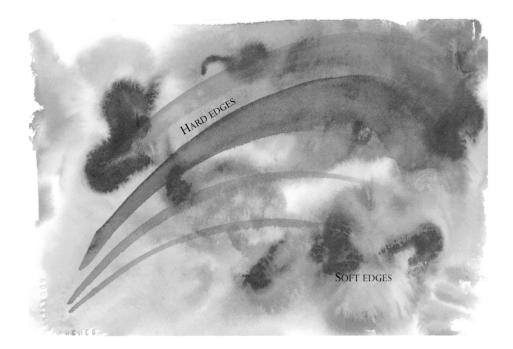

HARD EDGES

SOFT EDGES

Experience / Explore Softening Edges

Now I'd like you to play around losing and softening edges on purpose. Being able to do this comes in very handy for lots of different things—losing edges into the background, softening an edge that might seem to be popping out at you.

For this exercise you'll need two ¼ sheets of watercolor paper, or the backs of some of your earlier explorations. Try different ways to soften edges. Just play around, perhaps using paint first, then water; or water first, then paint. You can use one brush, rinsing it out before adding water, or two brushes, keeping the second just for the water. Fill both sheets of paper with your experiments. Try anything that occurs to you. See what happens. Get more paper if you need it.

Knowing how to make and change edges gives you yet another way to create depth—pushing something back by softening the edge, pulling it forward by making it sharp.

Knowing how to soften edges is also helpful when you're painting backgrounds and want to shift gradually from one color to another.

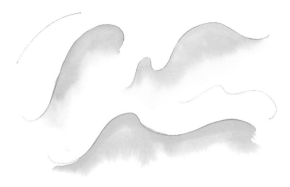

Try drawing some lines first.

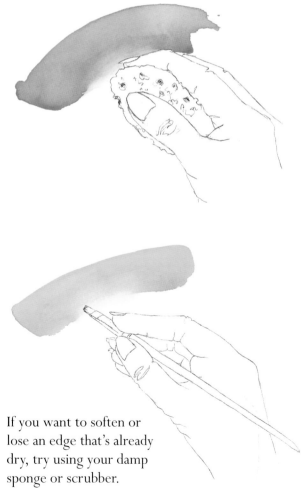

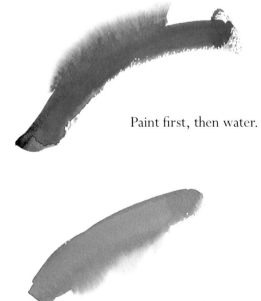

Paint first, then water.

Water first, then paint.

If you want to soften or lose an edge that's already dry, try using your damp sponge or scrubber.

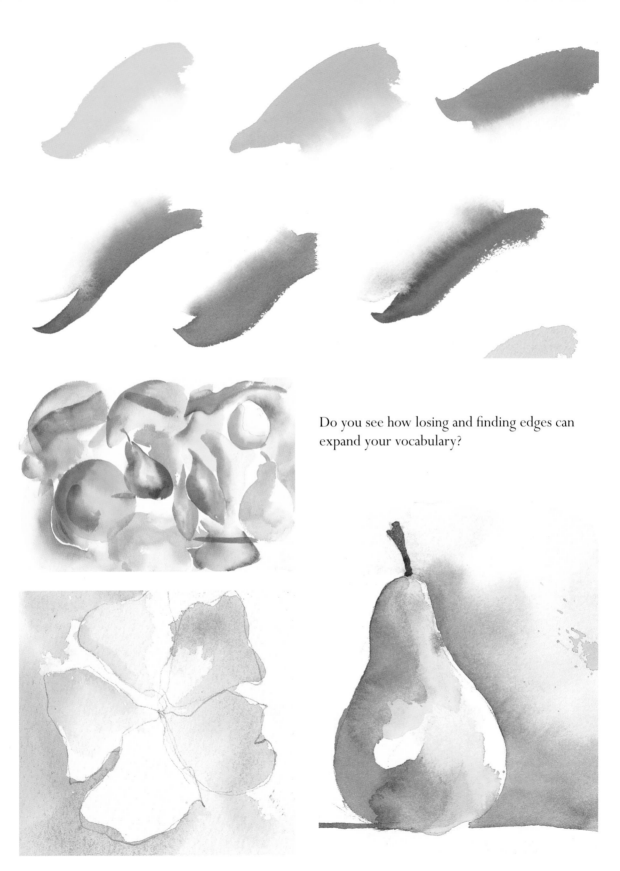

Do you see how losing and finding edges can expand your vocabulary?

Recovering an Edge

To "find" or recover an edge, place a mask of some sort—an index card or masking tape, for example—over the desired area and, with your sponge or scrubber, lift paint along the border, as illustrated here.

Try this on the sheets you're filling up now or one of your earlier examples. (Don't use the same masking edge twice, because water will seep under it and make things fuzzy.)

You would no doubt come up with this on your own if, at some point, you wanted to get an edge back and asked yourself, "How might I?"

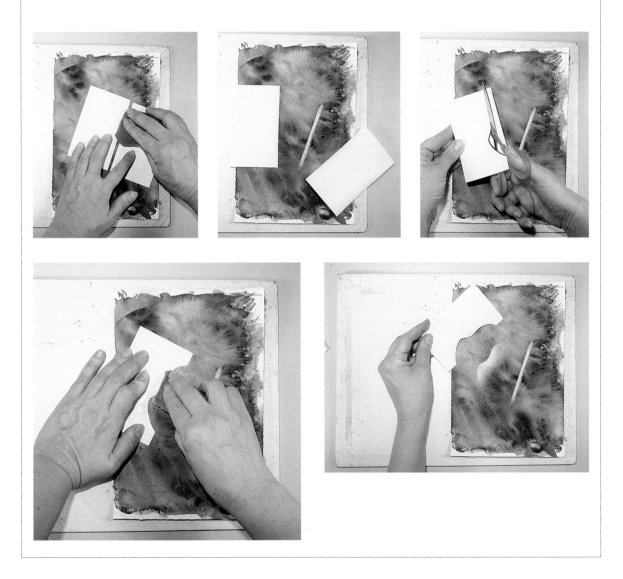

BACKGROUNDS

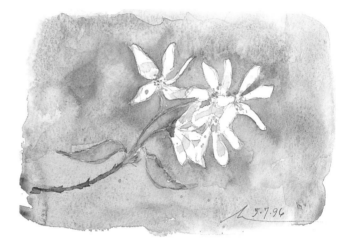

How do we talk about the space our subject is in, the space that surrounds our subject? What do you want to say? Of course, you don't have to say anything about it if you don't want to, and often in the beginning, students find that describing the subject itself is quite enough. Actually, leaving the paper white in the background is saying that you like it just the way it is.

When you do want to say something about the space your subject is in, you can do it the same way you've been talking about your subject: with color, value, and perhaps line. You can describe what you actually see, or you can make things up. You don't have to talk about the whole background, either; maybe you just want a little color to accent a certain edge, or a bit of dark to accent a light.

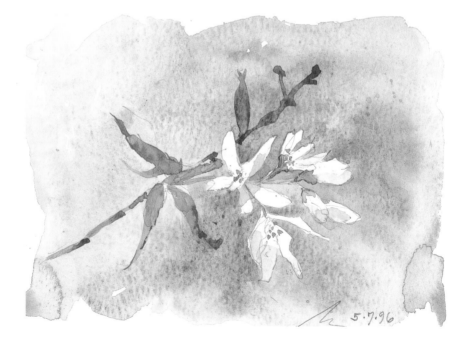

Experience / Explore Backgrounds with Color and Value

Choose some small paintings of flowers or other subjects without backgrounds (or cast shadows) that you've already done to play around on. (If you don't have any, do some.)

If you begin lighter rather than darker in the beginning, you'll have more options available to change colors by layering glazes. Relax—don't worry about how what you're doing is going to come out; just put one of your colors next to another and watch what happens. Have fun! Use your mats along the way to help you see more clearly how your painting looks.

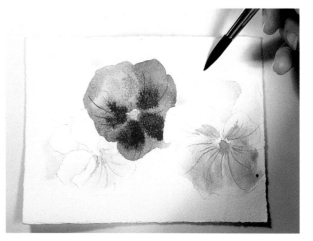

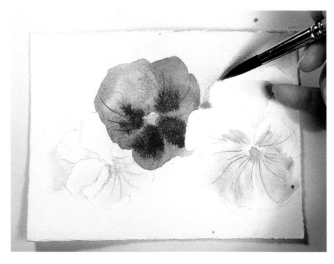

Here's my thinking: I want things soft in the background, so I use water.

Since the pansy is violet, I decide to try light orange (a near-complement) behind it.

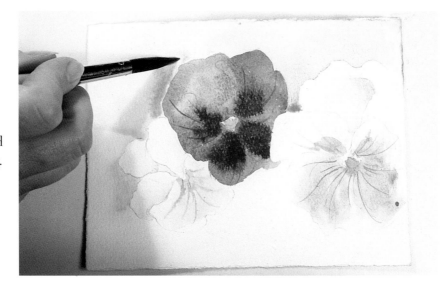

I like it and keep going.

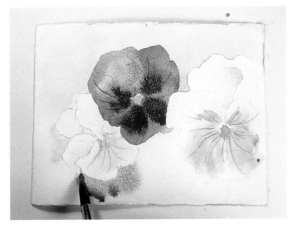

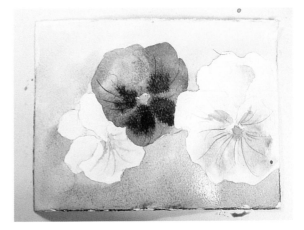

Now it's time for a change; let's see—behind the light flowers I try something darker.

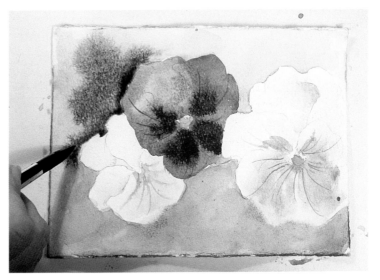

I want it a little darker up on the left, so first I wet the area, then drop in some color. That's enough for now.

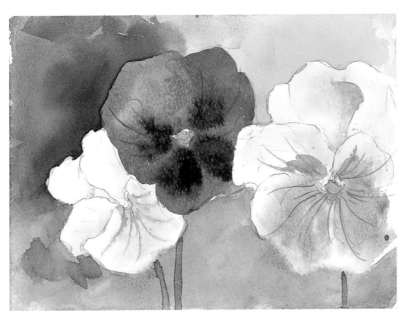

This is how it looks when it's dry.

Now for another one. I think I want a
background that says "sky," so I lay in a
light blue wash behind these sweethearts.

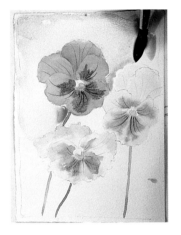

Here I'm wiping
my brush to
wick up a puddle
to the left of my
darkest flower.

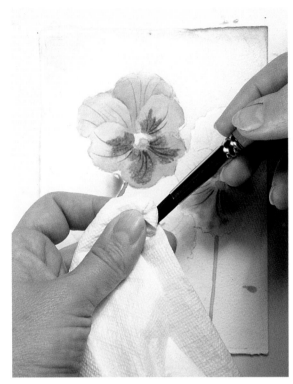

I continue
painting in
the back-
ground . . .

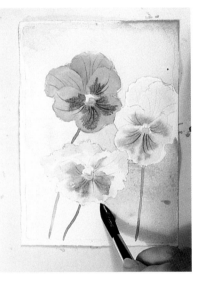

. . . till the end.

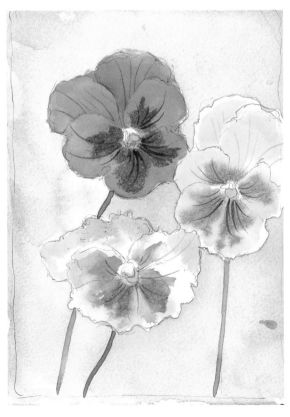

Try anything you want, noticing what you
like and what, if anything, you might want to
change. If you don't like one attempt, try glaz-
ing another color over it. You can paint with
water first if you like, or use it anywhere to
soften an edge. If a background you've painted is
very dark, you can lift color with your sponge
or scrub it out and try something else entirely.
Maybe you'd like to experiment in just one or
two areas instead of the whole background.
The possibilities are endless.

How Did It Go? What happened in your own explorations? Did you get one or two you like more than others? Do you like just some areas? Which ones? Are there any parts you might change? Is there anything you would try differently another time? Don't forget to give your paintings time to breathe; leave them overnight and let them surprise you in the morning. Here are examples by Betsey (below), me (right, top), and Mary (right, below).

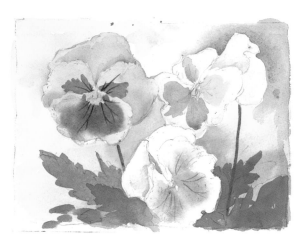

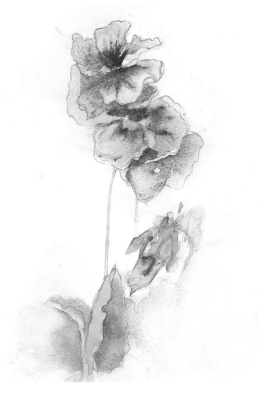

In the tulip painting at right, Mary used a complementary color in the background to contrast with the green leaves. Note the value contrast— the darker leaves against the pale red tint.

Describing Space with Line

Let's say you have a painting of a fruit or vegetable that's sitting on a horizontal surface such as a table or a windowsill, and you want to talk about how your subject relates to that surface. If you've painted in a cast shadow, you've already done that to a certain extent. You can say more by adding a line, which you can put anywhere. It doesn't have to be what you actually see; maybe there's no line at all. It doesn't matter—you can put a line wherever you want.

Experience / Explore Adding a Line

Get out a pencil and your eraser. Take a few of your studies and draw a line on them. Try it in different places. Go ahead and use a ruler if you want.

See how putting down just one line changes things, makes space and depth start to happen?

Another way you might explore various possibilities—compositions—is with tracing paper. Try tracing your drawing or painting and its border—the picture plane, the format—and exploring different ideas with line to see which ones you like best.

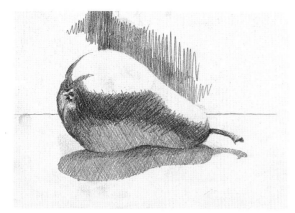

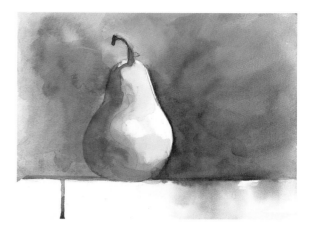

How Did It Go? Did you find places for the line that you liked? Did some work better than others? Did you notice the shapes ("negative" shapes, which we'll explore in the next chapter) you began creating both above and below the line?

Composition Rule Sneaking In

Dividing things unevenly is more interesting than dividing them evenly. In other words, don't put the line in the middle. But by now, it goes without saying that such "rules" are made to be broken; sometimes dividing a composition in the middle is exactly what

you want to do. As always, play around to see what you like.

Here's the same drawing with a line behind the subject in the middle; above it; and below it. Do you like one more than the others? Would you put the line somewhere else?

The Spirit of Adventure

Backgrounds seem to be a bugaboo for lots of beginning students. I think it's because there are so many things that can happen to affect a painting we were happy with and now don't like anymore. This happens all the time. It only means that you're temporarily back in the realm of product. When you become aware of this, zing yourself back to the realm of process by asking yourself, "What's going on here? What might I do?" You may have lost something, but you're on your way to finding something else; something other than what you intended has happened. It's OK.

Approach backgrounds in the same spirit of exploration as in your earlier playing, and your recent painting. Let them simply be another exciting aspect of the adventure.

Below are some background explorations from my sketchbook; above is one of Mary's.

Mary liked her painting of this tulip but was afraid to add a background, so she used a simple pencil line to suggest a space for the flower to inhabit.

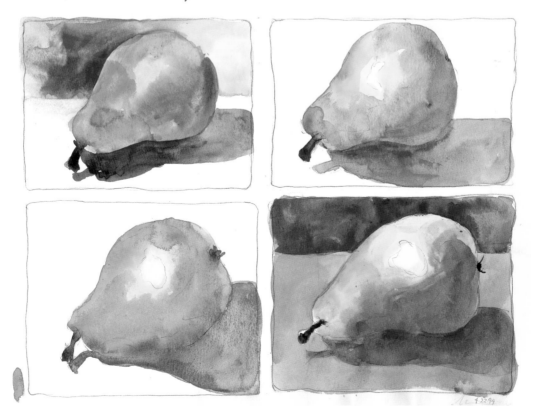

NEGATIVE SPACE

Ready for some more magic? In this chapter, we're going to revel in paradox—doing something that seems impossible when you think about it. We're going to imagine nothing, and then paint it! There's a deep metaphysical aspect to what's called "negative space" that begins to make itself felt and known when you draw and paint it.

Negative space refers to the shape(s) of the spaces in between or around a subject—in other words, the nothing. When we talk about what we see, the nothing is a part of it—a part that's as important as our subject. Our rational mind, being well grounded in the ways of the physical world, thinks of space as nothing, something intangible that exists between "real" things, separating them. The nothing is the atmosphere, the very breath of life, and when you draw or paint it, you find that this intangible stuff is actually connecting everything, that it is just as real— and here you are, painting it!

Experience/Explore Painting the Forest for the Trees

On a quarter sheet of water-color paper, paint some wide bands or areas of multi-col-ored washes, making them fairly light, like so.

When the washes are dry (a hair dryer will come in handy here), draw some tree shapes in pencil on them as you see here.

With your brush, fill in the little spaces between the shapes you've drawn with glazes of any color.

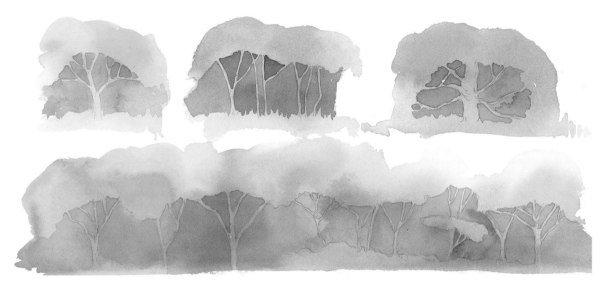

And voilà! Look what happens! Got the idea? As you paint behind your subject (painting the nothing, the negative space), your subject appears.

Try using your #10 or #12 brush. For the tiniest shapes, use just the tip. For the larger shapes, push down a little more.

This may be a little tricky at first. You are completely reversing the way you've always thought about painting things. Don't worry about it; just play around.

How Did It Go?
You were really out there, weren't you? Was it magic, or what? I just love this stuff.

Here are a couple of Linda's.

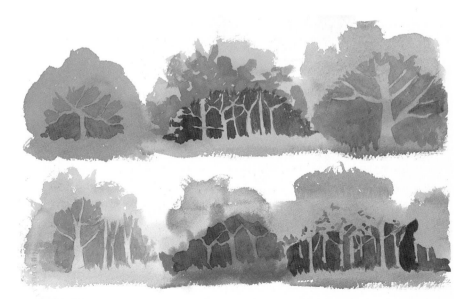

Experience / Explore Layers of Leaves

Now let's play with negative space in another way. Go gather some leaves.

On a quarter sheet (or one or two ⅛ sheets) of watercolor paper taped down to your work surface on all four sides, lay in a lovely, juicy, multicolored wash over the whole area. Dry it.

Then, with a pencil, draw or trace two or three leaf shapes (don't overlap them) and glaze around them, losing the edge as you move away from the leaves. Dry your paper.

Draw or trace two or three more leaf shapes so that they appear to lie under your first ones, overlapping but not drawing the lines on top of the existing leaf shapes. Then glaze around the new leaf shapes, losing edges. Dry your paper.

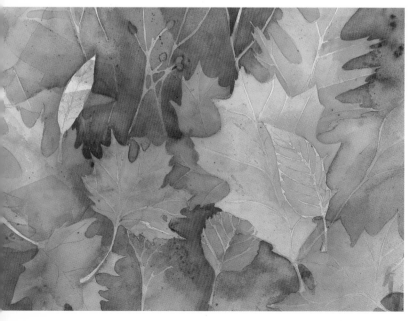

Build up (go down!) as many layers as you wish. If you get confused, don't worry. Just do whatever you do. The effort alone is opening up your pores. Have fun. Let yourself get lost in the experience.

Here's one of my explorations.

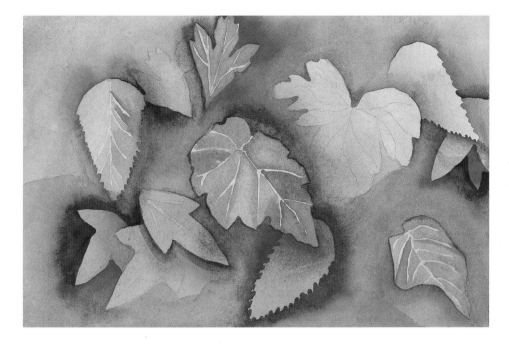

Above is an example by Wendy, and at right, one by Mary.

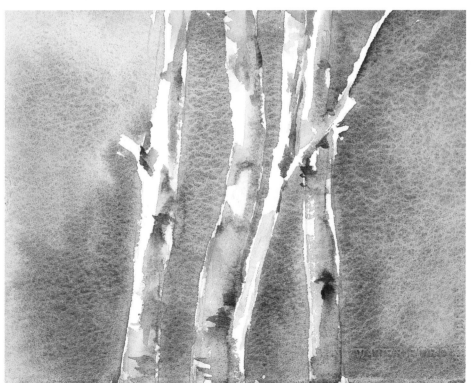

How Did It Go? Was it fun? Confusing? I find painting the "nothing" in this way particularly wild because what I'm doing seems impossible. With each layer of color I paint on top I'm mak-

ing the space deeper. I'm pushing it back, down, away. If you had a hard time with this, don't worry. Sometimes it takes a while to get it. Whatever you did counts.

Part III
CARRYING ON

NOW WHAT?

Well, I think by now you have the basic idea—playfully exploring and experiencing the connection between your inner and outer worlds. There are two books I highly recommend at this point: The Zen of Seeing *by Frederick Franck and* Drawing on the Right Side of the Brain *by Betty Edwards.*

Beyond that, carry on. Keep painting. Keep drawing. Fill your sketchbook and get another one. If you like, you can take yourself through this course again. You can start all over again with some new colors, playing with them and seeing what they do. Continue to explore things that call to you, perhaps trying two or three pears or flowers, having fun arranging and rearranging them. Continue working in series, having more than one piece of paper ready to go.

At some point you may feel like using larger pieces of paper. I've found that the desire for this comes naturally and doesn't need to be forced. When you're ready, you'll know it; you'll start to feel a little confined, like you need more room to say what you want to say.

You can scrub anything you don't want to keep under the tap with a nail brush, winding up with a new and

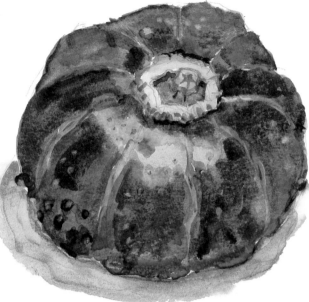

different surface to play around on. You could put a coat of white acrylic gesso on it and have still another surface to explore.

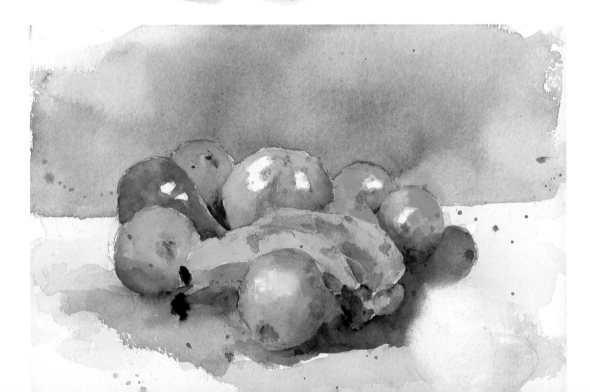

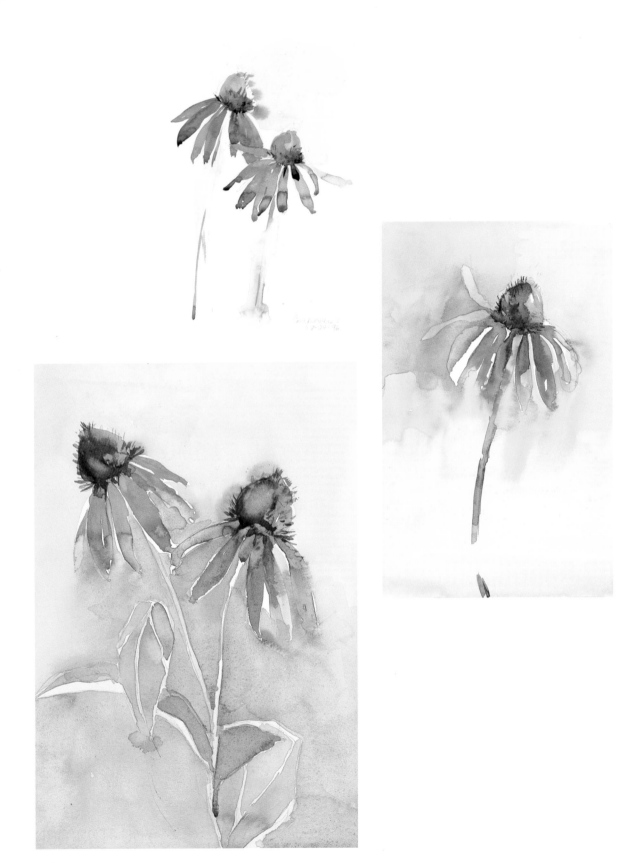

Opening the Door to Landscape

Step outside. Head right out with your gear and paint! Find a spot in your backyard or the park. Take a walk and stop when you see something that calls to you. Start small. Start simply. Start with whatever you are comfortable with. Use your small pads of paper, or just your sketchbook, and have fun. Play around. See what happens.

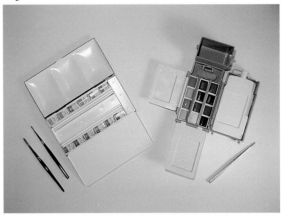

New Toys

Get yourself a small, portable palette to fill or a set of pan colors and have fun putting together a mini traveling studio to take on your next hike or trip. There are some wonderful little sets that are such fun to pop into your pocket, purse, or backpack. Plastic palette cups and empty film canisters are good for carrying a bit of water if your paint set doesn't come with its own bottle. You really feel like you've been somewhere when you've sat down and done a little painting or two. While recording your experience of being there, you're taking it in and letting it come back out, through you.

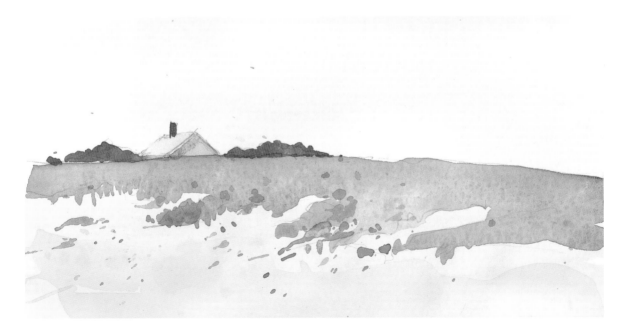

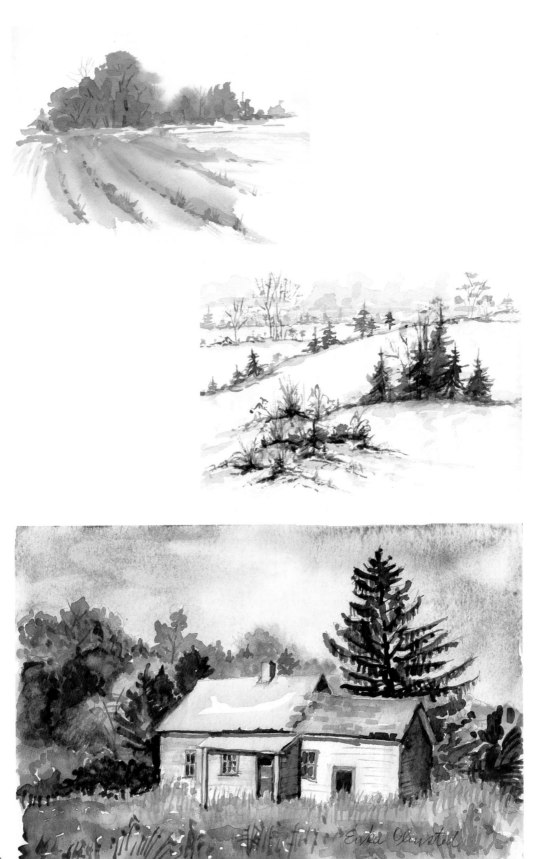

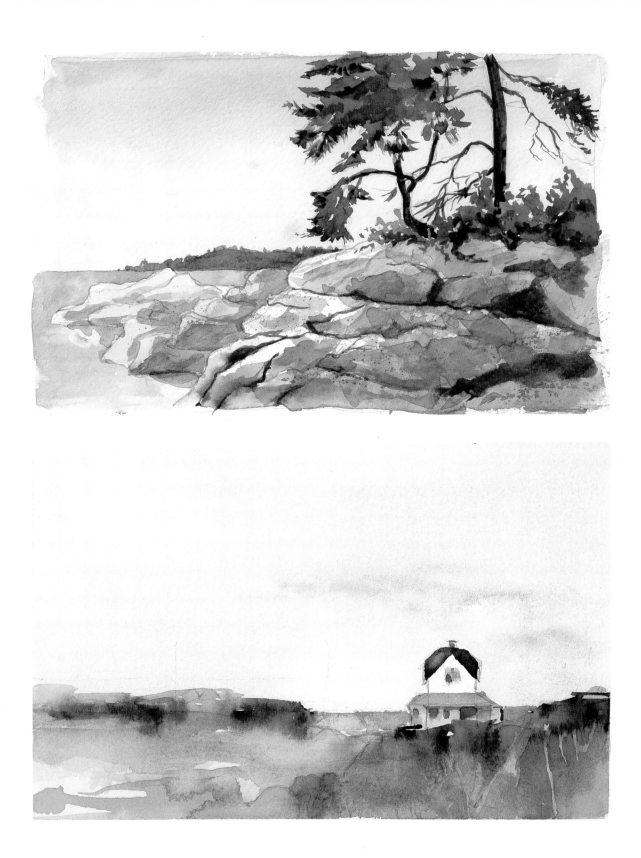

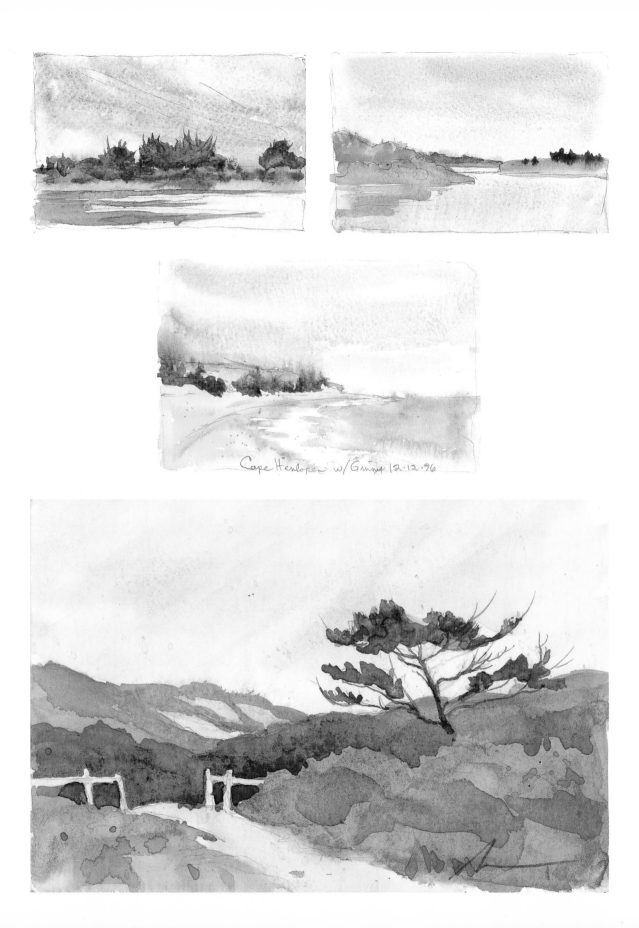

Cape Henlopen w/ Ginny 12·12·96

Jumping into the Deep End of the Pool

If you ever find yourself in a place where you feel you're in over your head, that there's more going on than you can possibly deal with and you're on the verge of total panic, don't worry—it's OK. It happens to everyone. Remember, you're here to enjoy yourself, so either "fake it" with a flourish, or go back to where you're comfortable. Go back to the shallow end of the pool and paddle around for as long as you need to.

Maybe paint that tree instead of the whole landscape, or just a wildflower instead of the whole field. Maybe paint the doorway or the geranium by the step instead of the whole building.

Just as you have to be able to touch down when you're learning how to swim, you have to be able to get your footing in painting too. Even though I've painted for years, there are days when I just don't feel particularly courageous, when drawing or doing smaller paintings is just the thing. So if the unknown gets a little too scary or you're just not feeling up to snuff, go back to where you're comfortable and have fun there. You'll feel more adventurous another day.

Taking Art Classes

If you aren't painting on your own as often as you'd like and know how much you enjoy doing it, take some beginning watercolor classes. I took three or four when I was starting out, then studied for two years with a teacher I really liked and attended a number of workshops—all beginning ten years after art school! Remember, this isn't really a linear trip; essentially, we're always beginning. The reason to take art classes is not so much to be taught how to paint as it is to get yourself to a place where you will be encouraged and supported while you do it.

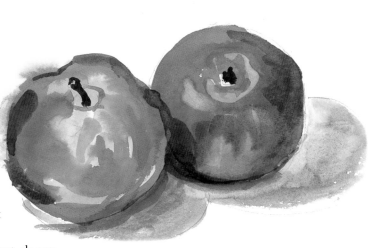

Showing Your Art to Others

When you decide to show your art to someone you trust, try not to say anything. I know this is hard, but try to let the art speak. If you feel an urge to rush right in and talk about everything that went wrong or that you don't like, stop yourself. When we make critical remarks about our own work, we literally take away the pleasure the other person is experiencing and feed his or her own inner critic. If someone happens to see one of your paintings before you're ready to show it and you feel the need to say something, try "It's in process"—because that's what it is; maybe you're not done working on it or don't know what to do next, or maybe it's finished and you just don't know it yet.

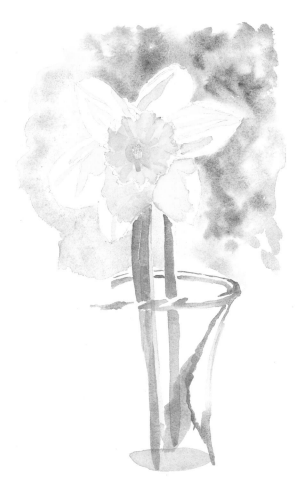

In Conclusion . . .

When you're drawing and painting, you connect with things in a way that's like no other. You feel good because it's fun. Because you're enjoying yourself. And, because when you're doing it, you have a concrete experience of being at one with the world.

So enjoy! And whenever you sit down to paint, and now and then while you're painting, enjoy the realization that some more magic has taken place.

Your wish has come true! Happy painting!

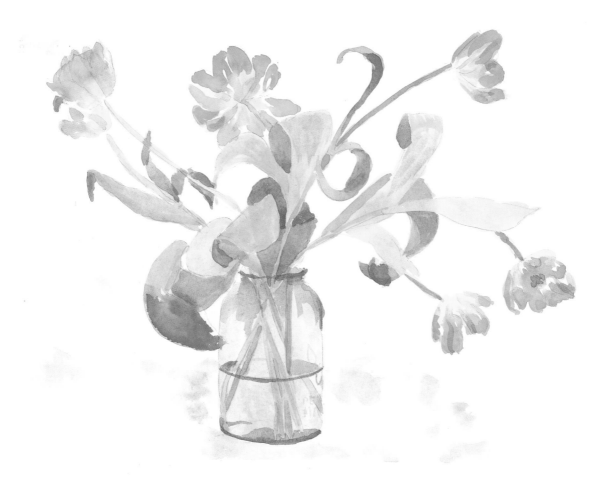

Index